images *of* nature

Women Artists

Andrea Hart

Published by the Natural History Museum, London

First published by the Natural History Museum
Cromwell Road, London SW7 5BD

© Natural History Museum, London, 2014

ISBN 978 0 565 09344 0

A catalogue record for this book is available from the British Library.

Designed by Mercer Design, London
Reproduction by Saxon Digital Services
Printed by 1010 Printing International Limited

Front cover: *Aglais urticae*, small tortoiseshell, *Tulipa* sp., tulip
Back cover: *Mangifera indica*, mango
Back flap: most likely *Aeshna cyanea*, southern hawker
Title page: *Magnolia* sp., magnolia
Contents page: *Paeonia* sp., peony

Contents

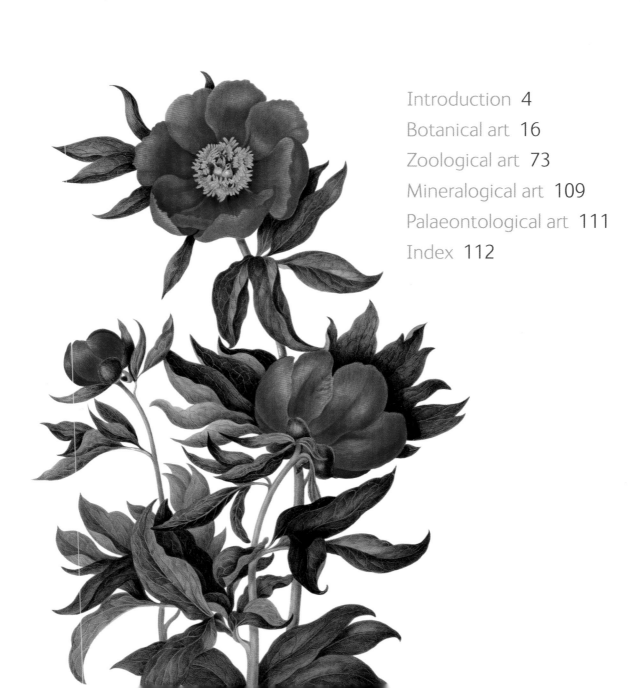

Introduction 4
Botanical art 16
Zoological art 73
Mineralogical art 109
Palaeontological art 111
Index 112

Introduction

This book is dedicated to, and celebrates the works of, some of the most accomplished women natural history artists of the last four centuries and these artworks have been carefully selected from the collections held in the Library of the Natural History Museum. From the seventeenth century right up to the present day, women have made important contributions to natural history art, science and education. Whilst their visibility, influence and individual life stories may not have been studied or acknowledged to the extent of some of their male counterparts, their work and involvement in the social, cultural and literary history of science and natural history remain significant. Whether they worked on their own, alongside their respective muses or struggled against stereotypical roles, it is through their illustrations, observations and careful documentations of the natural world that we continue to be amazed by its magnificent flora and fauna.

The backgrounds of the women who devoted much of their lives to natural history and art are varied. Many assisted male relatives with their scientific study and accompanied them around the globe, while others had their own scientific interests and travelled independently. There were those who were simply fascinated and enthused by the natural world around them and decided to record what they saw for their own enjoyment. Some worked in obscurity, had their contributions ignored or chose to remain anonymous, while others were praised and encouraged. In some cases the life of the artist has been well-documented, for others little is known. They range from the professionally trained and skilled scientific illustrators to the serious but accomplished amateurs, reflected in the significantly different techniques, styles and finishes used in the artworks. But what remains common to all is how the artistic ability of the women continues to inspire.

Artists and illustrators play an important role in all aspects of natural history. Whether they are required to make an exact copy of their subject, recording in detail the biology of a plant or

animal, or whether they are amateurs who, without professional constraints draw and record the natural world through their own artistic interpretations, for their own pleasure and at their own level of understanding. Although these personal discoveries of the natural world may be based on observation rather than theory, the results can be remarkable in their freshness of vision and in their uniquely beautiful and often detailed depiction. Olivia Tonge (1858–1949) is one such artist who recorded her travels in India with superbly vivid and colourful paintings of the natural, cultural and social history that she encountered.

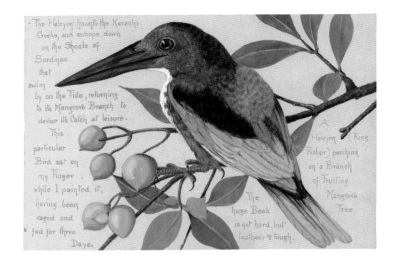

The illustrations in this book capture some of the best women natural history artists, both historical and contemporary, to serve up a visual feast of the never ending wonders of the natural world.

Halcyon smyrnensis
white-throated kingfisher

Olivia Tonge made two trips to India between 1908 and 1913 where she travelled widely, drawing and taking notes on what she saw. The Library holds 16 of Tonge's wonderfully colourful, vibrant and charming sketchbooks of the flora, fauna and ethnographic subjects that she encountered.

Olivia Tonge (1858–1949)
Watercolour on paper
1908–1913
178 x 258 mm

Science, education and the botanical influence

During the seventeenth and eighteenth centuries science was predominantly the preserve of wealthy amateurs and the educated middle classes. In Britain the subject was dominated by men, which is evident from the exclusion of women from many of the scientific establishments and societies at the time. The Botanical Society of London allowed women members from 1836 but it was not until 1905 that women were admitted to The Linnean Society and they were actively kept out of The Geological Society until 1919. Few women had access to the advantages and opportunities provided by the scientific community, so for the majority any involvement in science was in an amateur capacity only.

For those women who persisted and made science a professional career they were not made welcome. The biased viewpoints and barriers that were created within male-dominated scientific circles only served to increase these women's hunger for information and their motivation to undertake scientific study. They not only helped to popularise the study of natural sciences but made many significant breakthroughs that undeniably helped shape and cultivate ideas about the natural world, although for many their work remained unrecognised

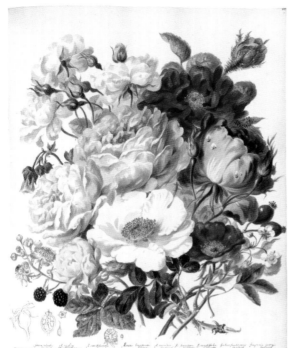

at the time. Beatrix Potter (1866–1943) for example, failed to win scientific recognition for her ground-breaking study of fungi but she went on to gain major recognition for her illustrated animal story books. Mary Anning (1799–1847) was one of the first female palaeontologists and despite a humble background and limited education, became a respected and frequently consulted authority on geology. Her understanding of comparative anatomy and her collecting ability saw her supply vast numbers of fossil specimens to some of the most eminent geologists of the time. However, it has only been in recent years that her work has been truly acknowledged, and her contributions have been fundamental to geological science.

The professionalisation of science during the nineteenth century provided opportunities for women to attend public lectures and scientific demonstrations, although there were feelings of unease that the attendance of women at serious scientific discussions could put at risk the professional status of the societies concerned. There was also a worry that women might learn too much. John Lindley, a professor of botany in London and a key figure in education, sought to make the distinction between 'polite botany' and the more serious application of 'botanical science', which at the time was considered solely for the thoughts of men and not women. Regardless of such views, the increase in availability of books and magazines helped women to pursue scientific study. In doing so, they were able to contribute to the scientific knowledge and dissemination of the science of the time and, for some, to fulfil their individual aspirations and desire for intellectual recognition. As the study of science required the assistance and inspiration that only a competent tutor could offer, an individual's progress ultimately came down to their social class.

Letters and correspondence have long been an additional means of science writing – a way to exchange information and communication. They were an excellent method of learning for those with little or no access to public institutions of science. The scientific correspondence and observations of the zoologist Dorothy Elizabeth Thursby-Pelham (1884–1972) with the Antarctic explorer Cherry Apsley-Gerrard, assistant zoologist on the British Antarctic

Expedition (1910–1913), regarding her study of penguins is a prime example of the usefulness and importance of this form of scientific communication. Her penguin illustrations are held at the Natural History Museum.

The development of new scientific instruments such as the microscope in the late seventeenth century caused excitement, particularly as it enabled the capturing of greater visual information. For those fortunate enough to have access to a microscope in either a professional or amateur capacity, it made possible the observation of previously hidden life processes and physical forms. This led to countless biological discoveries as it allowed for a more detailed view and interpretation of nature. Agnes Ibbetson (1757–1823) used microscopes extensively to pursue her research into plant physiology as did Gulielma Lister (1860–1949) for her work on the Myxogastria (slime moulds), which she undertook with her botanist father. Lister's interest in microscopes was unsurprising as she was the granddaughter of a microscopist and was also the niece of the surgeon Lord Joseph Lister who used microscopes in developing his system of antiseptic surgery in the late 1860s. Both Ibbetson and Lister were artists in their own right and so were able to accurately reproduce what they observed.

Botany was opened up to a whole new audience in 1753 when Carl Linnaeus published his two-volume *Species Plantarum* ('The Species of Plants') which was to be the starting point for modern botanical nomenclature. Jane Colden (1724–1766), a North American botanist, used the newly developed system to classify and compile a catalogue of the flora found in her home city of New York. In 1843, Asa Gray (1810–1888), one of the most influential botanists of the nineteenth century and a contemporary of Charles Darwin, wrote of Colden being the 'first botanist of her sex in her country'. Another woman who used her understanding of the Linnaean principles was Mary Delany (1700–1788), who created thousands of mosaics of paper flowers that not only showed remarkable dexterity but were scientifically accurate.

The relative simplicity of the Linnaean system combined with the feminisation of botany and writers who wrote specifically for the female audience, enabled generations of women to understand the concepts of botany more easily and pursue it as a hobby. A shared enthusiasm for finding plants and learning about them saw the establishment of many nineteenth-century natural history societies and field clubs, where like-minded individuals could go to share their science, observations and interests. This also led to a huge increase in the publication of books, illustrations, poetry and essays on botany and other floral hobbies and pastimes. The hand-coloured illustrations in such books increased their popularity further. Botanical art became a key component of fashionable life which led to the publication of many instruction

Rosa bracteata, Rosa canina, Rosa punicea, Rosa centifolia, Rubus fruticosus, Fragaria vesca, Geum rivale, Rosa indica, Rosa sulphurea

Elizabeth Twining was the daughter of the well-known tea merchant Richard Twining. She published in an ambitious two-volume folio publication titled the *Illustrations of the Natural Order of Plants* (1849–1855) which she both illustrated and lithographed. Her accomplished drawings are accompanied by manuscript descriptions.

Elizabeth Twining (1805–1889)
Watercolour on paper
*c.*1827
400 x 260 mm

manuals on botanical drawing and painting, especially for those who could not afford tuition. It also provided a way in which science and art could be seen to be brought together and was approved by the promoters of science for women as it was seen to improve both social and cultural values.

This increase in the popularity of botany encouraged women to become authors and illustrators in their own right, with many of their books aimed primarily at children, women and general readers. Sarah Bowdich (1791–1856) was highly praised for the artistic skills of her illustrations as well as her taxidermy skills, whilst Elizabeth Twining (1805–1889), of the Twinings tea merchant family, was not only a talented botanical artist, but in addition dedicated a huge amount of time to writing material for both informal and formal learning in schools. Jane Loudon (1807–1858), a self-taught artist, wrote and illustrated many popular botanical books and gardening manuals. Her books were well-liked as she wrote in a very personal manner and avoided complicated terminology.

The authorship of books provided an opportunity for women to obtain an income. Elizabeth Blackwell (1700–1758) was neither a trained botanist nor artist but she was encouraged by Sir Hans Sloane and others to publish an up-to-date herbal book using the medicinal plants that were growing in the Chelsea Physic Garden. She did this to raise the funds to release her husband, Alexander, from debtors' prison. Elizabeth not only drew the illustrations but also etched, engraved and hand-coloured them. Alexander, who was a physician by trade, assisted her with the descriptions. The book was incredibly successful and is an important historical record of the medicinal plants of the time. She remains one of the few published women on record up until the mid-eighteenth century.

Family and relationships

Family influences and social status have to some extent long dictated the options and opportunities in education and careers for women and girls. During the eighteenth and nineteenth centuries most middle-class girls were educated at home, usually in the hands of a governess or by their mothers. For those who wished to study science, it was often the man of the house, as husband or father, who assumed this role. The influence on those whose fathers were academics or scientists can be seen in the chosen pursuits and achievements of the daughters. Women, as mothers, were also influential in instructing their children and in their roles as wives, often assisting in their husband's scientific pursuits and endeavours.

Anna Children's (later Atkins) (1799–1871) father was a scientist and she helped to illustrate not only his work but also Jean-Baptiste Lamarck's *Genera of Shells*, which was published in 1833. She was friends with William Fox Talbot the British inventor and photography pioneer, and with his help became the first woman to print and publish a photographically-illustrated book containing amazing blue-toned photograms of marine algae. Henry Woodward, who was the Keeper of Geology at the British Museum (Natural History) from 1880 to 1901, taught science and illustration to his daughters. Alice Bolingbroke Woodward (1862–1951) was a prolific illustrator and produced drawings for scientific works and children's books that included Lewis Carroll's *Alice in Wonderland*. Her sister Gertrude Mary Woodward (1861–1939) was a proficient watercolour artist whose illustrations included the Piltdown fossils that were part of the famous twentieth-century palaeoanthropological hoax. Sarah Ormerod's (1784–1860) proficiency as a botanical artist no doubt influenced her elder daughter Georgiana E. Ormerod(1823–1896) and led to her becoming a talented entomological artist.

During the seventeenth and eighteenth centuries, daughters in particular benefited from their fathers' botanical interests and work. Many assisted their fathers and were required to create botanical illustrations and flower paintings. Alida Withoos (*c*.1660–1730) is one of the earliest female artists represented in the Library's collections and was trained by her Dutch father Matthias Withoos in still-life art and flower painting. Painting tuition was expensive at that time so she trained in his studio. Rachel Ruysch (1664–1750) is another notable artist whose father was an anatomist and botanist. She was apprenticed to the prominent Delft painter Willem van Aelst, and the skill and quality of her work saw her inducted into the Painters Guild in The Hague, the Netherlands in 1701. Withoos and Ruysch were among the very few female Dutch painters during the seventeenth century, a period that saw the Dutch at the forefront, with their discoveries, gardens and sumptuous artwork.

Ann Lee (1753–1790), the daughter of the London nurseryman and author James Lee, was instructed by Sydney Parkinson who was the artist on board Cook's HMS *Endeavour* voyage (1768–1771). She assisted her father by drawing many of the exotic plants that he cultivated in his London nursery as well as doing

Cylindrophyllum calamiforme, mesembryanthemum

Ann Lee was the daughter of James Lee, a successful commercial nursery owner. Her volume of drawings of mesembryanthemum hold scientific value as, in the absence of specimens, they were the only representation of the species. Mesembryanthemum were very fashionable in the latter part of the eighteenth century.

Ann Lee (1753–1790)
Watercolour on vellum
1776–1778
400 x 285 mm

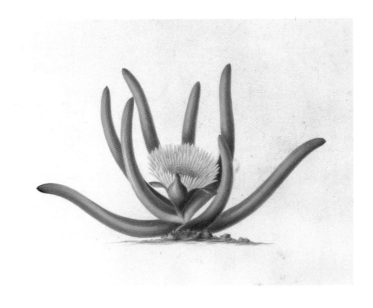

Aglais urticae, small tortoiseshell, *Tulipa* sp., tulip

Inspired by her passion for flowers and insects (in particular butterflies), Maria Sibylla Merian made a self-funded expedition to Dutch Surinam where she studied and painted her findings. At the time entomology was in its infancy. The quality of work continues to be admired today and she is recognised as one of the most gifted artists of her generation.

Maria Sibylla Merian (1647–1717)
Insect paintings by Dutch Artists 17th–19th Century
Bodycolour on vellum
c. late seventeenth century
290 x 211 mm

drawings for his friends and their private collections. Such illustrations played a significant role in popularising and promoting new plant discoveries and are an indication of what was being cultivated at the time. James Lee also commissioned other female artists including Mary Lawrance (*fl.* 1790–1830) to whom he sent specimens of new plants so that she could illustrate them for his catalogues. Similarly to other female botanical artists of the time, Lawrance also taught botanical drawing to supplement her income.

For some wives and partners, their roles were more concerned with the scientist than his science and so they were merely regarded as participants in their husbands' careers which often included accompanying them to scientific meetings. Others played a more active role in the provision of illustrations or proofreading manuscripts; their efforts, however, were not always acknowledged. Sarah Abbot (*fl.*1790s) assisted her husband Charles Abbot in the publication of his *Flora Bedfordiensis* (1798) but is not mentioned in the credits. Others were duly credited for the work they did, including Hilda Margaret Godfery (1871–1930) who assisted her husband Masters John Godfery by illustrating the plates for his seminal work on British native orchids, which gained increased prominence as a result of her excellent illustrations. Mary Turner (1774–1850) illustrated her husband Dawson Turner's monograph on British seaweeds and, in keeping with the family tradition, the Turner daughters were also artists, and drew and engraved for the Royal Botanic Gardens in Kew.

Travel and exploration

The desire for travel, exploration and the concept of wilderness was, as it continues to be, a fascination for many. The importance of illustrating new animals and plants in the absence of photography saw dedicated artists travelling on board early voyages of exploration. Their role was to produce illustrations of the discoveries made so that they could be recorded and published along with the written accounts of the voyage.

Jeanne Baret (1740–1807) was an extraordinary woman who joined the explorer Louis Antoine de Bougainville's voyage around the world in 1766. She cunningly disguised herself as a man so that she could serve as an assistant to the ship's naturalist Philibert Commerson. Regarded as an excellent botanist, she is credited as being the first woman to have completed a voyage of circumnavigation. The plant *Solanum baretiae* was named in her honour.

The German artist Maria Sibylla Merian (1647–1717) was born at the beginning of the great age of botanical exploration, when very few artists, and even fewer women, went on expeditions.

A painter and engraver by trade, Merian spent two perilous years between 1699 and 1701 exploring and painting in the Dutch colony of Surinam with her daughter. Entomology became her study of choice and following her self-funded expedition she published a book *Metamorphosis Insectorum Surinamensium* in 1705. It focused on the life cycle of insects that she had observed from her studies and both the text and her sumptuous illustrations were of scientific merit. The book was also considered a botanical book due to the skilful depiction of the host plants that she drew with the insects. The volume serves as a great example of how scientific accuracy need not be sacrificed for something to be artistically pleasing.

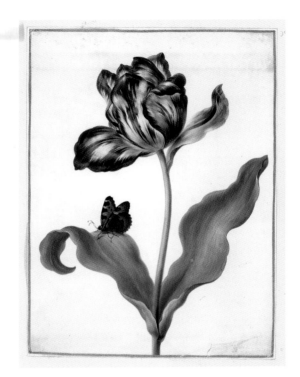

Others, similarly to Merian, managed to fund their travel by independent means. Marianne North (1830–1890) travelled on her own and, despite collecting thousands of plants and drawing hundreds for Kew Gardens, was never able to win any acclaim from the scientific community. Her travel accounts were published posthumously. Margaret Elizabeth Fountaine (1862–1940) fastidiously recorded her life experiences and observations as well as her extensive travels. Through her notebooks the reader learns about her incredibly emotionally complex life – she wrote that when she began them at the age of 16 'the education of women was so shamelessly neglected, leaving the uninitiated female to commence life with all the yearnings of nature quite unexplained to her'. It was her wish that her diaries, along with her magnificent collection of over 22,000 butterflies, remain embargoed until the 15th April 1978 – 38 years after her death and exactly one hundred years since she started them. Her four notebooks held by the Library contain illustrations and scientific studies of the life cycles of butterflies and demonstrate her artistic talents wonderfully.

Greatly influenced by the wealthy elite's craving for the rare and unusual, the eighteenth century in particular saw a significant influx of new species of plants into Britain. Royal and aristocratic women would use their wealth to collect such plants and stock their gardens and estates with them for both pleasure and botanical study. There were also public displays such as in the Glass House at Kew, which allowed all of society to experience and be inspired by the emerging rich global floral wealth. This period also saw the growth of many of the world's great natural history museums.

For those who travelled with their husbands, many worked on natural history projects and collected and drew specimens that were sent back to England. Lady Edith Blake (1845–1926) is one such artist who, despite having been born into wealth, was disinherited by her family because of her husband Henry Blake's lower social status. In the employ of the Colonial Service, he travelled with his wife to many exciting parts of the British Empire including Jamaica, where he served as Governor between 1889 and 1897. It was during her time in Jamaica that Edith combined her natural history interests and artistic skills. Her artwork remains a scientific legacy as her 196 illustrations provide one of the most extensive records of Jamaica's Lepidoptera.

Travel and exploration in a scientific capacity continues apace today as there are still many exciting discoveries to be made. Capturing and understanding the world's biodiversity and ensuring the conservation of its inhabitants and ecosystems remain key scientific endeavours that continue to use the records and accounts of past travellers and explorers. Margaret Mee (1909–1988) is one of the best known explorers of the twentieth century. Her paintings of rare and beautiful Amazonian plants and her campaigning to highlight the deforestation in Brazil have been globally recognised.

The art of scientific illustration

The use of drawings has long been recognised as a key tool for the promotion of understanding and communication within scientific papers. The growth of science from the eighteenth century onwards and the desire to share and communicate discoveries made the importance of illustrating observations, theories and research a necessity. When brought together with illustrations, scientific subjects and concepts can be more easily visualised and understood.

At its core, scientific illustration strives to represent truly the subject that it is portraying to ensure its correct identification and its subsequent naming and classification. Linnaeus's system of classification for example called for a more accurate and clinical style of botanical illustration. This showed the structures of the flower and its fruit to allow the correct identity of the plant to be determined. Accuracy is of the utmost importance as a beautiful but inaccurate illustration, just like an unlabelled specimen, is useless to science. This does not mean that it should lose any sense of beauty in the process. For science, however, meticulous detail through observation remains paramount as there is no place for purely decorative images, which many of the previous great flower paintings were.

It was commonplace in the twentieth century for women to be employed as professional artists in the colouring of prints, engravings, illustration of textbooks and in working with book and print production. The longest running botanical journal, *Curtis's Botanical Magazine*, has employed numerous acclaimed women artists since its first issue in 1787 and has seen Matilda Smith (1854–1926), Lilian Snelling (1879–1972) and Margaret Stones (b.1920) as its principal artists. Many female illustrators, however, worked in relative obscurity compared with their male counterparts and those who did illustrate professionally were typically underpaid or were rarely acknowledged. There are many drawings and illustrations within the Museum's collection that are signed by women but whose life stories and careers are impossible to trace.

Grace Edwards (*fl.*1875–1926) was employed on an unofficial basis by the Entomology Department at the Natural History Museum to prepare illustrations and models of specimens. The stunning illustrations of African bloodsucking flies she produced for Ernest Edward Austen (an English entomologist, who specialised in Diptera and Hymenoptera), at the beginning of the twentieth century demonstrate the painstaking detail required for scientific illustration on a minute scale. The Museum also commissioned artists to produce artworks for a range of

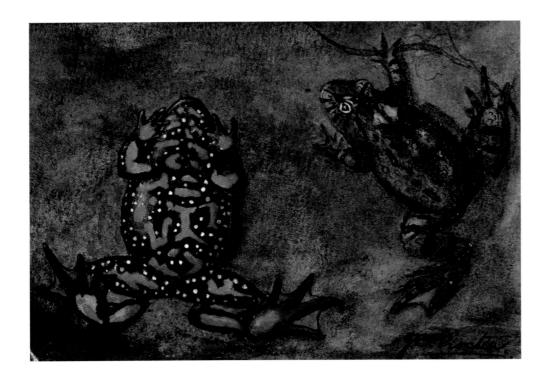

Bombina bombina, European fire-bellied toad

Fascinated by reptiles and amphibians from an early age, Joan Beauchamp Procter became a brilliant and respected herpetologist. She curated the collections at the Natural History Museum before becoming curator of Reptiles and Amphibians at London Zoo. Her artistic abilities were demonstrated at the Museum where she designed models, showcases and postcards, and at London Zoo in her building designs. The European fire-bellied toad is found across mainland Europe, and northern and central Asia. Its bright orange and black striped belly serves as a poison warning to its enemies.

Joan Beauchamp Procter
(1897–1931)
Watercolour on paper
*c.*1920s
176 x 246 mm

educational products and gallery designs. They include G. W. Dalby's (*fl*.1960s) brightly coloured jellyfish, Barbara Nicholson's (1906–1978) oversize wallcharts representing the United Kingdom's ecological and floral diversity, and Joan Beauchamp Procter's (1897–1931) illustrations of frogs and toads for a range of postcards. Although, tragically, Procter died at the age of 34 due to a lifelong illness, she had become an internationally recognised herpetologist. After working at the Museum under the Supervision of the then Keeper of Reptiles and Fishes George Boulanger between 1917 and 1923, she went on to become the first female curator of Reptiles at London Zoo. It was there that her artistic flair and technical abilities were employed in her designing the Reptile House and other areas of the Zoo.

Historically, the illustration of animals has not been as popular as plants and shells, with the more memorable zoological illustrations tending to be those that are not necessarily accurate. The early published illustrations of animals were usually drawn from poorly preserved specimens or from the artist's imagination of how they thought the subject would look in real life, especially in their depictions of animals from foreign lands or oceans. Mammals and birds, especially, had the tendency to encourage an anthropomorphic approach, which saw human-like emotions, postures and expressions creep into them. Albertus Seba's *Cabinet of Curiosities* (1734–1765) and Michael Boym's *Flora Sinensis* (1656) are good examples of this. In Europe, the introduction of zoos provided a way for some artists to observe live animals for the first time, which gave them an advantage over their predecessors. One of the earliest female zoological artists in the collection is Sarah Stone (*c*.1760–1844) whose exquisite artworks of exotic birds, many unknown to science at the time, were technically accurate and remain important scientific records. Elizabeth Butterworth (b.1949) is a modern-day bird artist whose attention to detail, combined with her knowledge of the subject succeeds in capturing the brilliant plumage of macaws, parrots and cockatoos.

Along with coloured illustrations, black and white line drawings continue to serve an important role in scientific illustration especially, when showing anatomical detail. Stella Ross-Craig (1906–2006) was a prolific botanical artist and taxonomist who predominantly drew such illustrations. Her botanical knowledge, artistic training and consistency of quality made her one of the few botanical artists who could transform dried herbarium specimens into scientifically accurate and vibrant illustrations of living plants. Whilst Ross-Craig contributed many watercolours over a span of 50 years to *Curtis's Botanical Magazine*, she remains best known for her monumental work, *Drawings of British Plants* (1948–1973), that included black and white illustrations of almost the entire British flora.

Conclusion

The digital age of reproduction has long replaced the era of fine hand-coloured engravings and pictures, and the use of photography and other digital platforms has largely replaced scientific illustrations as the main method for recording nature. Although digital media has allowed the natural world to be explored, portrayed and accessed in a huge array of different formats, it has its limitations and cannot replace the detail that can be captured by an artist's hand or imagination. The natural history artist is by no means redundant as natural history illustration is as popular and diverse as ever. The need for scientific illustration also continues to exist in research, especially in portraying detailed anatomy and in demonstrating the full layers of a subject.

Botanical illustration remains the most popular genre of natural history illustration, with the membership of many organisations, Floriligeum Societies and illustration classes predominantly made up of women. Women artists continue to illustrate for scientific journals and books whilst the fashion and design world continues to take inspiration from patterns and images of nature. Wildlife art is still very much a sought after commodity that continues to push the boundaries of art forms and technique.

The study of the natural world is not just about describing its inhabitants and ordering species. The broader scope of natural history science includes recognising how species evolve and adapt to different environments, their origins and evolution and the relationships and impact that humans have on them. Illustrations and art continue to help portray the importance of the natural world through conservation, science and education. Many women have played significant roles and this book serves to give a glimpse into the lives and achievements of women who have made some outstanding contributions.

Bibliography

GATES, Barbara, *Kindred nature: Victorian and Edwardian women embrace the living world.* University of Chicago Press, 1998.

LIGHTMAN, Bernard (ed.), *Victorian science in context.* University of Chicago Press, 1997.

SHTEIR, Ann B., *Cultivating women, cultivating science: flora's daughters and botany in England, 1760 to 1860.* Johns Hopkins University Press, 1996.

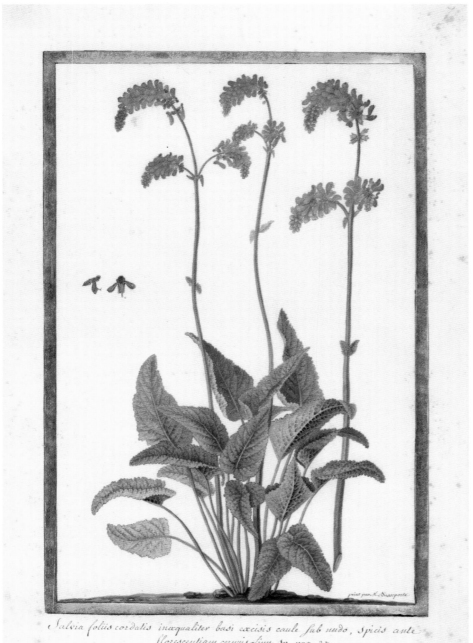

Salvia nutans, nodding sage

Madeleine Basseporte spent her entire life in Paris where she was a pupil of the acclaimed botanical artist Claude Aubriet. Following his death she succeeded him as Royal Painter to Louis XV. Aubriet also painted on vellum and would frame some of his paintings with a distinctive gold edge as Basseporte has done with this painting of a salvia.

Madeleine Basseporte (1701–1780)
Watercolour on vellum
c. mid-eighteenth century
416 x 283 mm

Mesembryanthemum sp.

Alida Withoos was an accomplished artist who was trained by her artist father, Matthias, in still-life painting and botanical drawing. She assisted Jan Moninckx with his monumental *Moninckx Atlas* (1686–1709), which depicted 420 plants from the Hortus Medicus garden in Amsterdam.

Alida Withoos (*c*.1660–1730)
Watercolour on paper
c. late seventeenth century
440 x 332 mm

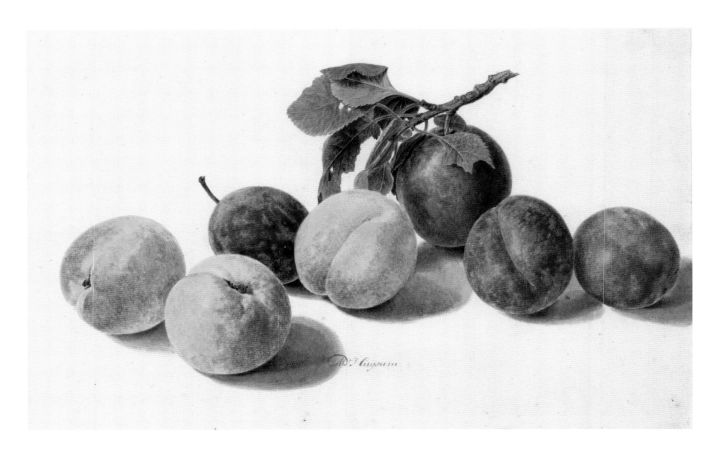

Prunus armeniaca, apricot and *Prunus domestica*, plum

Maria van Huysum came from a dynasty of Dutch flower painters at a time when Holland was renowned for its floral paintings. Still-life painting, as opposed to scientific illustration, provides the artist with increased freedom as to the arrangement of their objects as demonstrated here in van Huysum's composition of apricots and plums.

Maria van Huysum (*c*.1696 to after 1760)
Watercolour on paper
c.1750s?
205 x 326 mm

Zephyranthes atamasco, rain lily

Mary Moser was a contemporary of Clara Pope and Margaret Meen (other prominent artists of the time) and was one of only two women founding members of the Royal Academy in 1768. Her drawings were well executed but are considered flower paintings as opposed to scientific studies of botanical subjects.

Mary Moser (1744–1819)
Watercolour on paper
c.1770–1796
465 x 315 mm

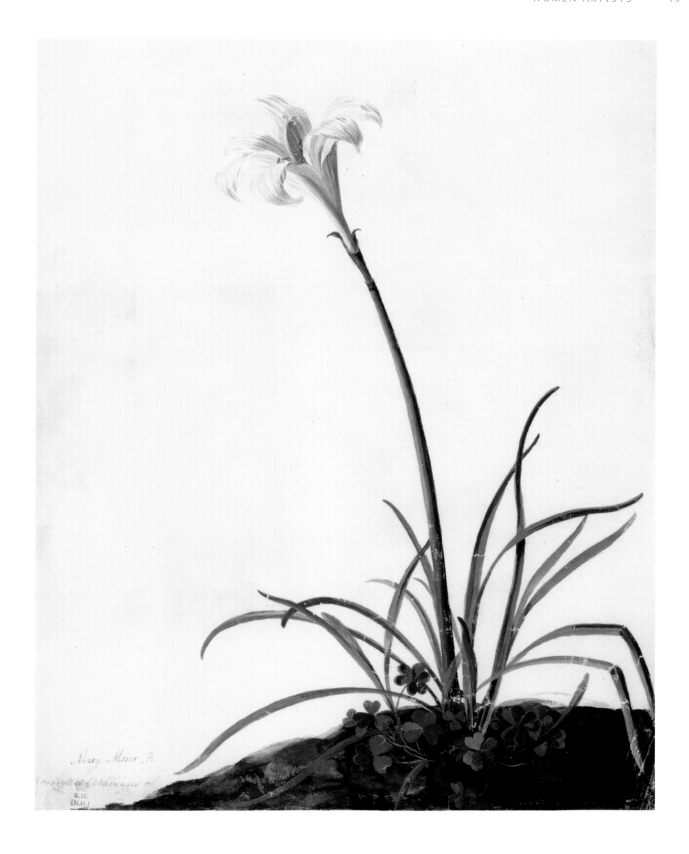

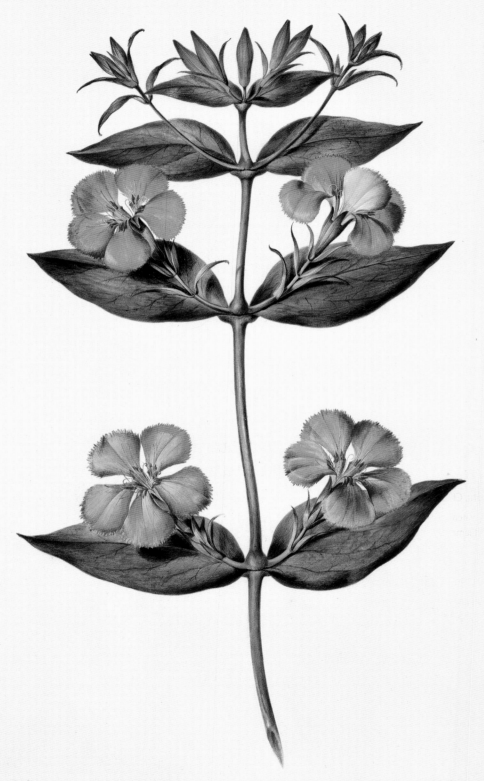

Lychnis coronata

Gletz pinxit 1777

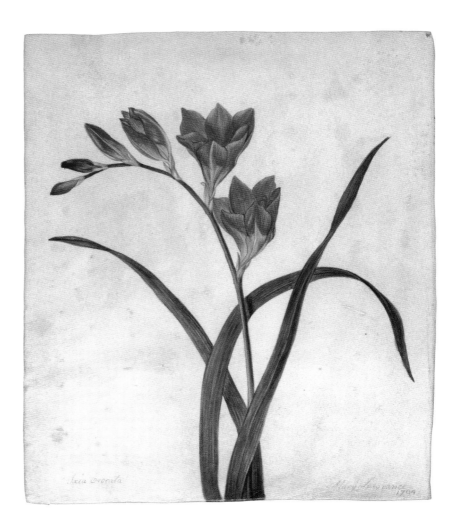

Lychnis coronata, Chinese lychnis

Gertrude Metz's watercolours were drawn from plants growing in Kew Gardens and James Lee's nursery in Hammersmith. Botanical illustrations played a significant role for nursery owners wishing to popularise new plant discoveries to amateur gardeners. *Lychnis coronata* is in the Caryophyllaceae family and is native to China.

Gertrude Metz (1746–1793)
Watercolour on paper
1777
522 x 369 mm

Tritonia crocata, flame freesia

Mary Lawrance taught botanical illustration at a time when flower painting was a socially desirable accomplishment for ladies. She obtained specimens from nurseries and gardens and her paintings were published in books as well as being exhibited at the Royal Academy. The horticulturist Robert Sweet named *Rosa lawranceana* after her. The sweet smelling *Tritonia crocata*, flame freesia, is part of the iris family and is native to South Africa.

Mary Lawrance (*fl.*1790–1830)
Watercolour on vellum
1794
243 x 204 mm

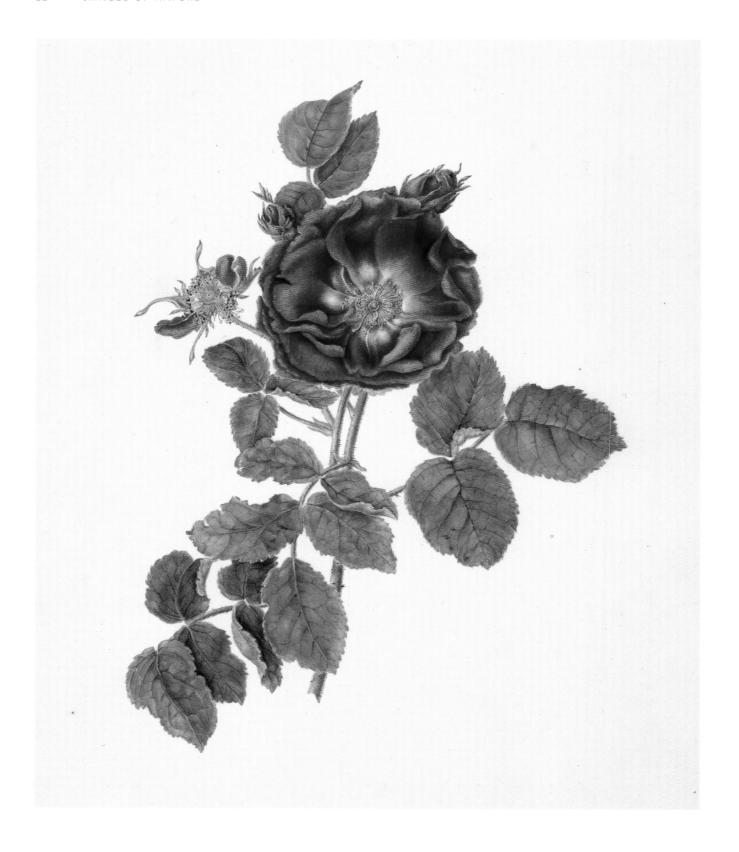

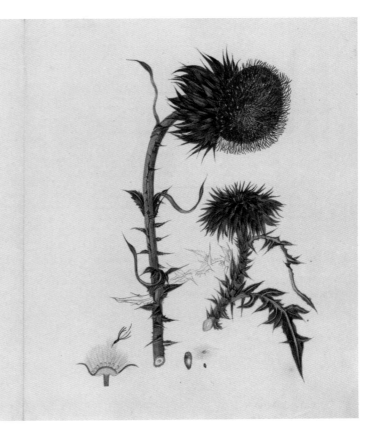

Rosa sp., rose

Margaret Meen was a prolific and highly gifted amateur artist who created hundreds of flower illustrations during her lifetime. She also taught the painting of flowers and insects.

Margaret Meen (*fl.*1775–1824)
Late eighteenth to early nineteenth century
Watercolour on card
457 x 325 mm

Carduus nutans, musk thistle

There are 882 paintings of British plants in the collection of Ellen Hawkins. The paintings are of considerable merit and are accompanied by detailed and accurate descriptions on the opposite side of the sheet. The red-purple flower heads of the milk thistle, which can produce over 1,200 seeds, are observed to droop to a 90˚ to 120˚ angle once the stem of the plant is mature.

Ellen Hawkins (*fl.*1821–1868)
Watercolour and ink on paper
c. mid-nineteenth century
Text and image 263 x 416 mm

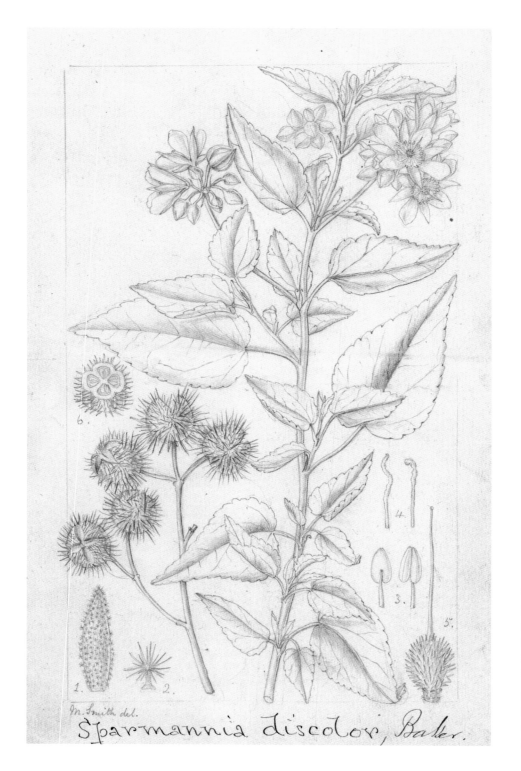

Sparmannia discolor

Matilda Smith was born in Bombay and contributed over 2,000 illustrations to *Curtis's Botanical Magazine* and other publications. This drawing demonstrates her technical skills using graphite.

Matilda Smith (1854–1926)
Graphite on paper
c.188?
211 x 131 mm

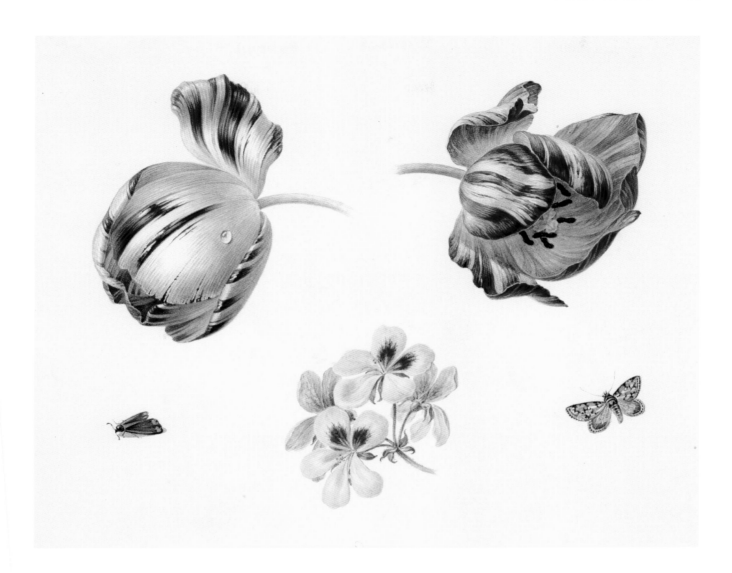

Tulipa sp., tulips

Married to the Dutch painter and drawing master Pieter Barbiers, Maria Geertruida Barbiers specialised in painting flowers and fruit. Tulips were one of the main exports of the Netherlands from the mid-seventeenth century. Their popularity and cultivation saw the rise of 'tulip mania', and as a result they became a very popular flower for artists to draw.

Maria Geertruida Barbiers (née Snabilie) (1773–1838)
Watercolour on paper
*c.*1800s
243 x 321 mm

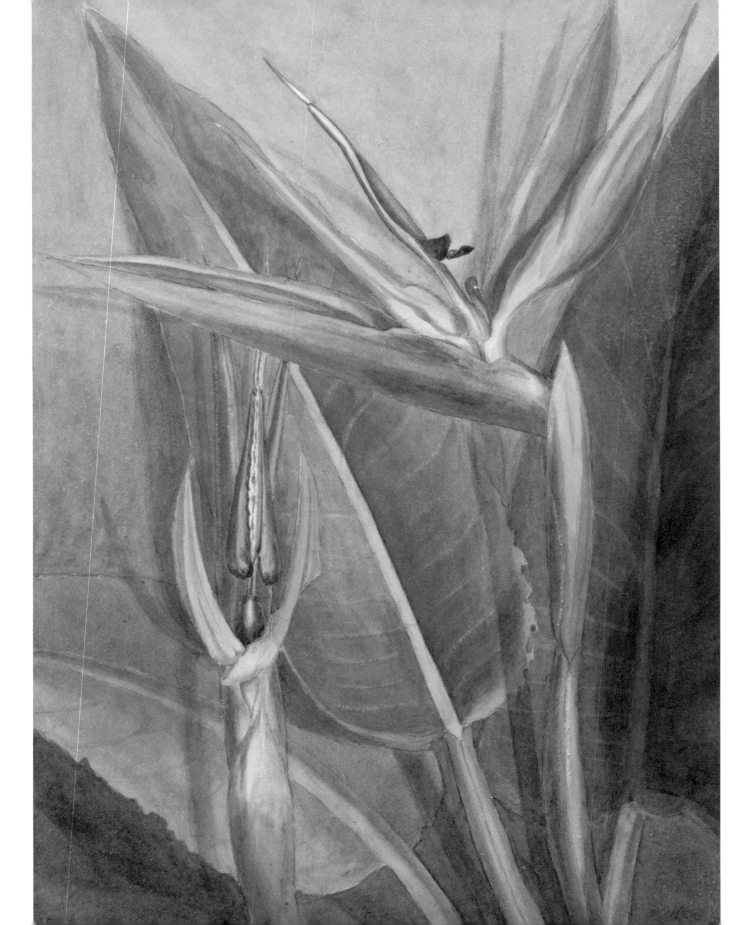

Strelitzia reginae, bird of paradise flower

The strelitzia is a native plant to South Africa, where Emily J. Balston painted and her husband William Edward Balston, a palaeontologist, collected Devonian fossils. It has become a very popular ornamental plant that can grow up to two metres in height.

Emily J. Balston (née Whitehead)
(1848–1914)
Watercolour on card
1880–1913
310 x 227 mm

102. *Ricinus communis*, castor oil plant, 103. *Arbutus* or *Gaultheria*, wintergreen, 104. *Glycine apios*, potato bean

Jane Colden is considered the first American-born woman botanist. She collected and described plants in her home city of New York where she completed line drawings of the plant leaves. Her accompanying notes give details of the medicinal uses of many of the plants, along with the quantity used and the method of administration used by the local people.

Jane Colden (1724–1766)
Pen and ink on paper
Mid-eighteenth century
305 x 183 mm

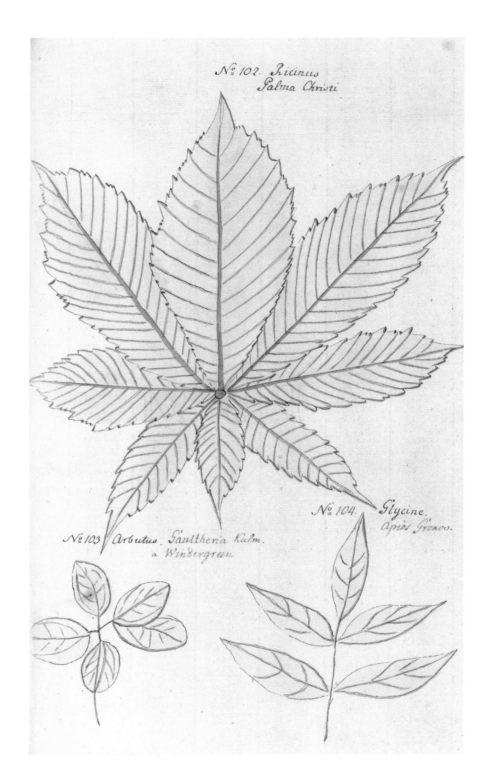

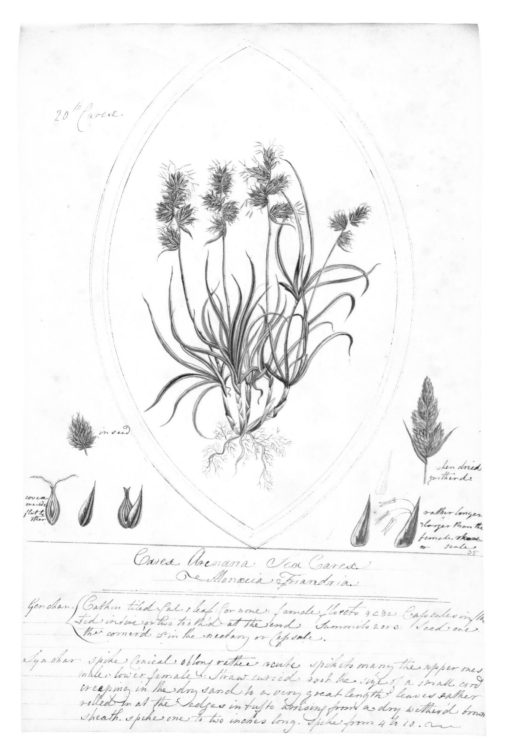

Carex arenaria, sand sedge

Agnes Ibbetson undertook experimental botany with the use of her microscope and published many essays on plant physiology. Her unpublished drawings of grasses are accompanied by botanical descriptions and scientific observations.

Agnes Ibbetson (1757–1823)
Watercolour on paper
*c.*1809–1822
463 x 282 mm

Inula helenium, horse-heal

The soft-edged and light watercolour technique of Frances Anna M. Phillipps is typical of the British botanical style of her time. Victorian women took to botany with an extraordinary passion – filling albums with watercolours and drawings of flowers became a favourite pastime for many.

Frances Anna M. Phillipps (1786–1863)
Watercolour on paper
1815
207 x 143 mm

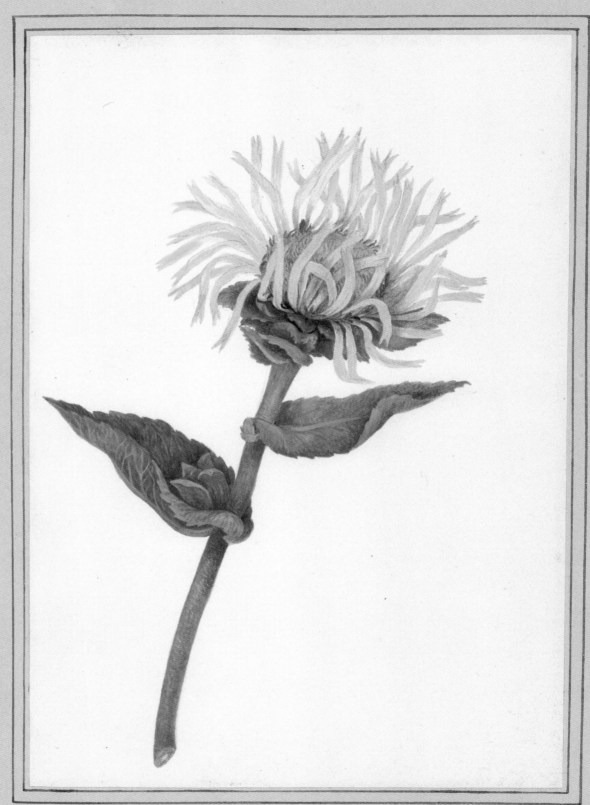

Barmouth 1815.

Inula Helenium.

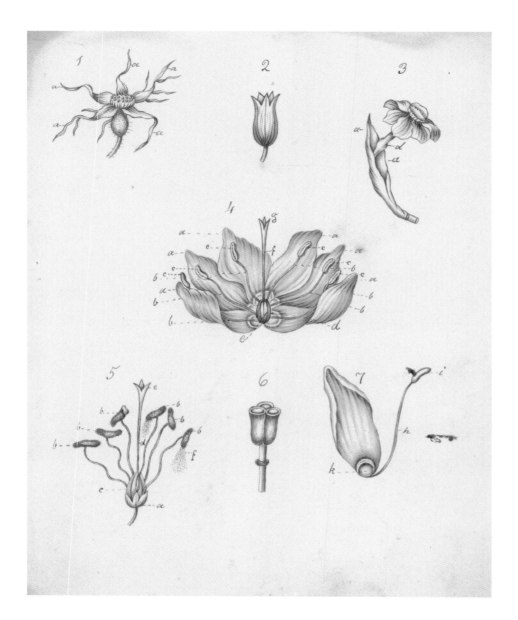

1. *Rosa* sp., 2. *Primula* sp., 3. *Narcissus* sp., 4. *Fritillaria imperialis*, 5. Sexual organs of a flower, 6. *Fritillaria imperialis*, 7. *Fritillaria imperialis*

It is thought that Lucy Hardcastle was the illegitimate daughter of Erasmus Darwin (1731–1802). Hardcastle published a book titled *An introduction to the elements of the Linnaean system of botany, for young persons* (1830) to simplify and help young readers understand the Linnaean classification system (the taxonomy of Carl Linnaeus). Her simple graphite illustrations depict some of the parts of a flower required to make an accurate taxonomic identification.

Lucy Hardcastle (1771–c.1835)
Ink on paper
c.1820s
229 x 196 mm

Paeonia sp., peony

Clara Pope is considered one of the most talented botanical illustrators of the nineteenth century. Her large-scale and bold watercolours of peonies and camellias are incredibly accomplished and continue to be admired by present-day botanical artists.

Clara Pope (c.1768–1838)
Bodycolour on card
1821
728 x 516 mm

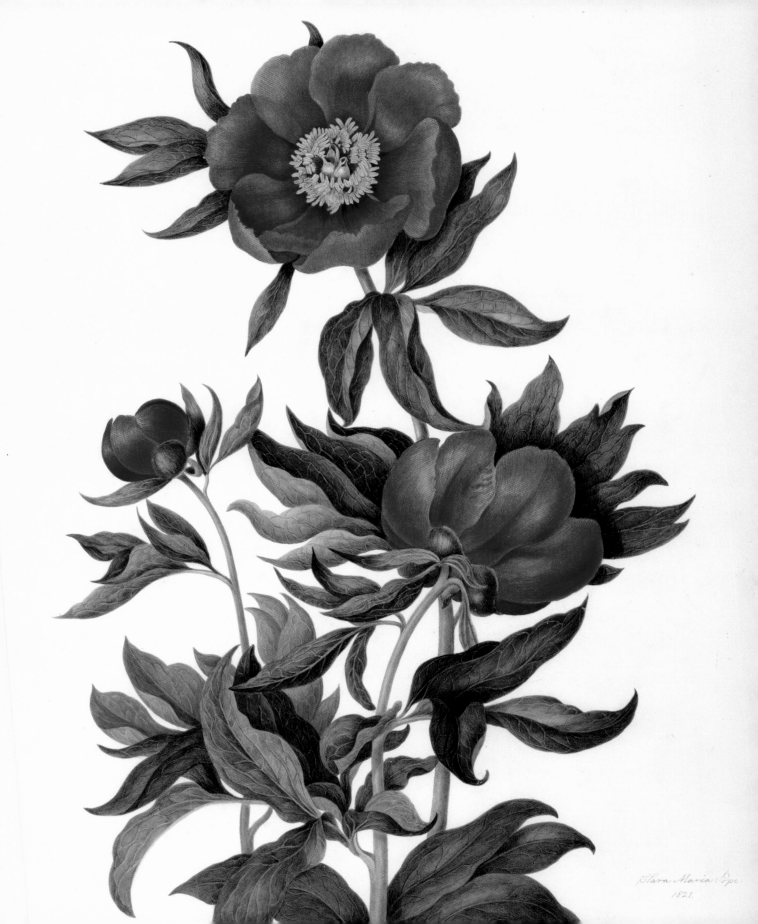

Clara Maria Pope
1821.

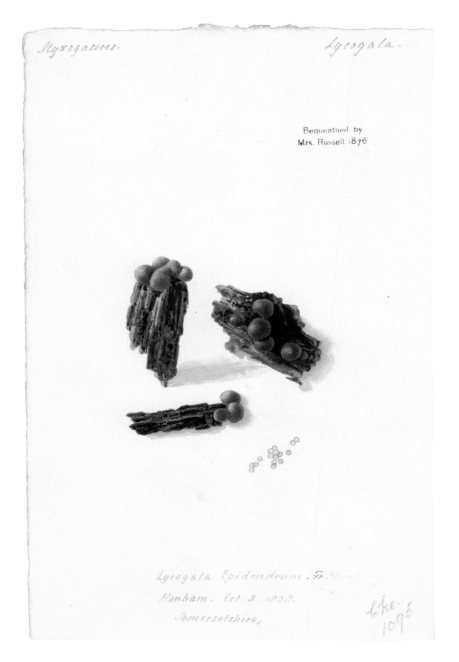

Lycogala epidendrum, wolf's milk
(a slime mould, Myxogastria,
Amoebozoa)

A member of the Botanical Society of
London, Anna Russell was predominantly
interested in the fungi around Kenilworth
where she lived, studied and drew.
Commonly known as wolf's milk,
Lycogala epidendrum is a slime mould
that occurs on damp, rotten wood.
Before it reaches maturity it contains a
pink, paste-like fluid that is excreted if
the outer wall is broken.

Anna Russell (née Worsley) (1807–1876)
Watercolour on paper
*c.*1838
227 x 147 mm

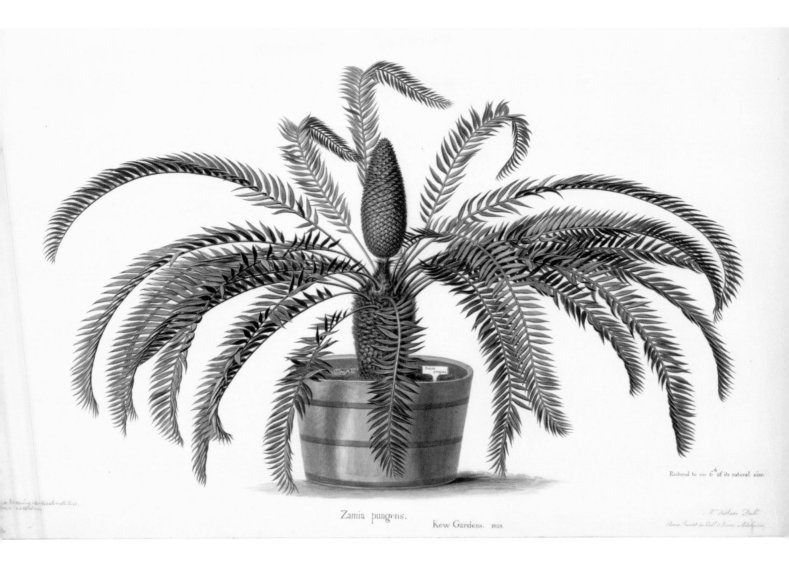

Zamia pungens.

Kew Gardens. 1833.

Reduced to one 6ᵗʰ of its natural size.

Encephalartos longifolius

Augusta Innes Withers displayed her drawings at the Royal
Academy. Her drawings of *Encephalartos longifolius* and its seed
cone are among the largest in the library collections. Originally
named *Zamia pungens* by William Aiton in 1813, it was changed
when Prof. J. G. C. Lehmann created the new genus name
Encephalartos in 1834.

Augusta Innes Withers (c.1791/2–1876)
Watercolour and bodycolour on paper
1839
511 x 710 mm

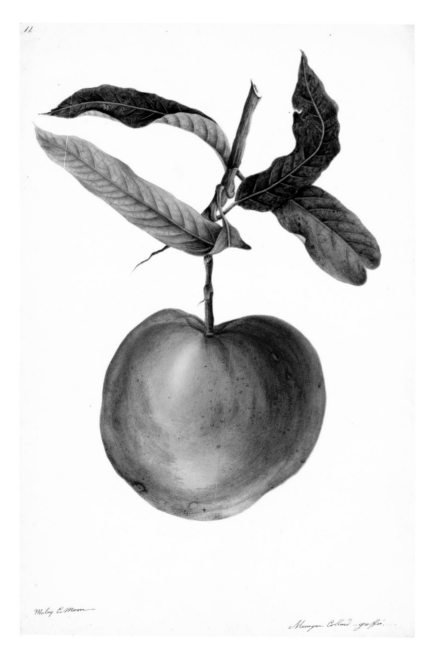

Mangifera indica, mango

The Library holds 12 watercolour drawings of mangoes grown in Mauritius and illustrated by Maley C. Moon. They were presented to the Museum by Lady Anna Barkly to whom one of the drawings was inscribed. Mangoes come from the tropical fruiting trees in the flowering plant family Anacardiaceae.

Maley C. Moon (Mrs William Moon)
(*fl.*1840s)
Bodycolour on card
*c.*1840s
444 x 280 mm

Hibiscus rosa-sinensis, rose mallow

Little is known about Isabel Drought. The hibisicus she painted is part of the mallow family Malvaceae. Its large, distinctive trumpet-shaped flowers make it a popular showy flower that is also attractive to hummingbirds, bees and butterflies. The species is a national symbol for many nations and is also used in a variety of beverages, in paper making and can be dried and eaten as a foodstuff.

Isabel Drought (*fl.*1847–1851)
Bodycolour on board
1847–1851
417 x 340 mm

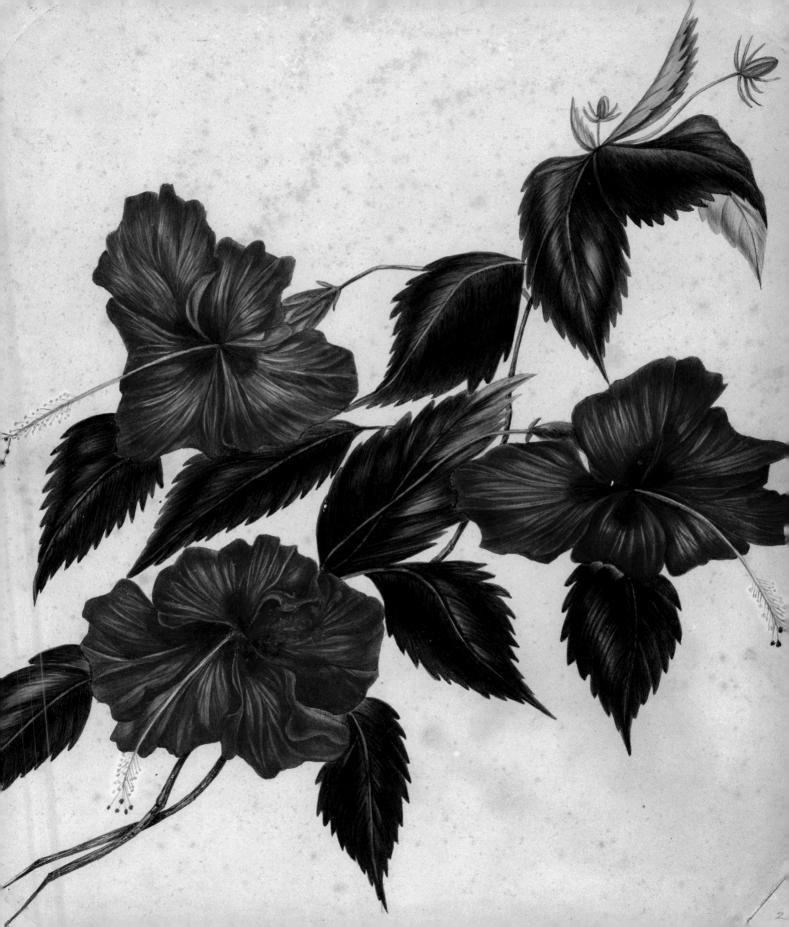

Iris foetidissima, stinking iris, roast beef plant

Harriet Moseley lived in Worcestershire where she studied the local flora. *Iris foetidissima* is one of two native species of iris in Britain. It gets its common names of 'stinking iris' and 'roast beef plant' as it gives off an unpleasant 'beefy' odour if its leaves are crushed or bruised.

Harriet Moseley (*fl.*1836–1867)
Watercolour on paper
*c.*1848
222 x 150 mm

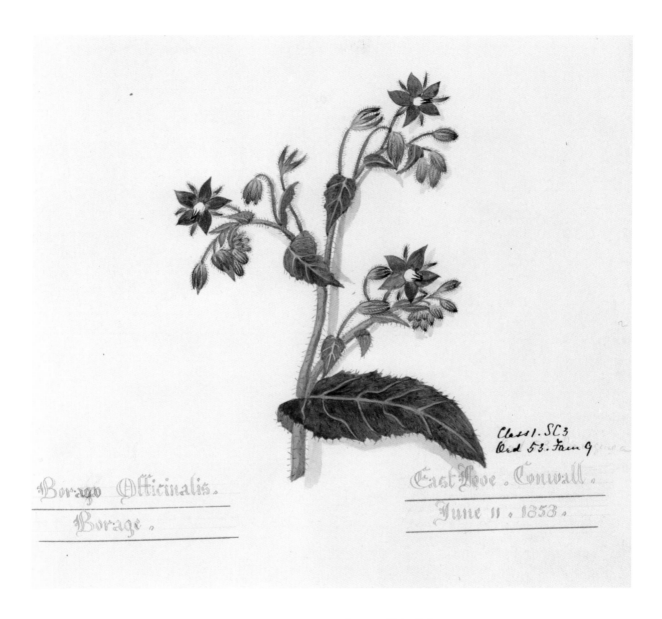

Borago officinalis, borage

Before becoming a nun, Margaret Plues, who was born in Yorkshire, published a number of her botanical studies including ferns, fungi and grasses. Borage is also known as star flower. It has edible leaves and its seeds are cultivated for borage seed oil.

Margaret Plues (*c*.1828–1901)
Watercolour on paper
1858
280 x 235 mm

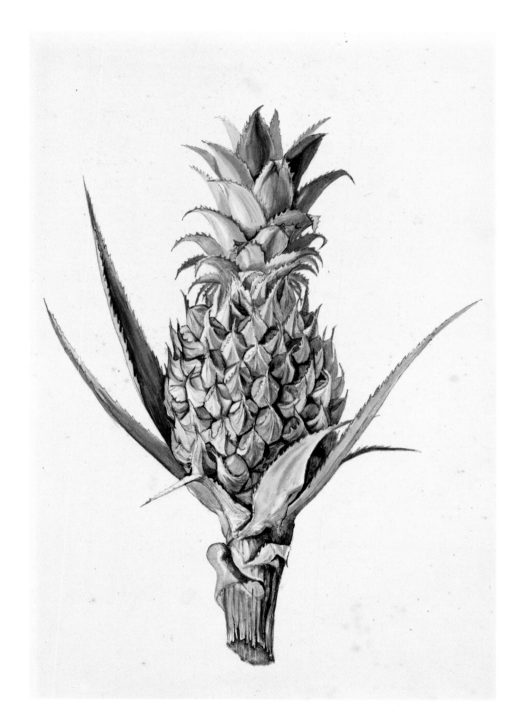

Ananas comosus, pineapple

Similarly to other wives at the time, this artist identified herself as Mrs C. W. W. Bewsher, her husband's name. This pineapple illustration is from a collection of 22 drawings of plants and fruit that Bewsher and her husband found on Mauritius.

Mrs C. W. W. Bewsher (*fl*.1872–1884)
Watercolour on paper
c.1872–1884
294 x 192 mm

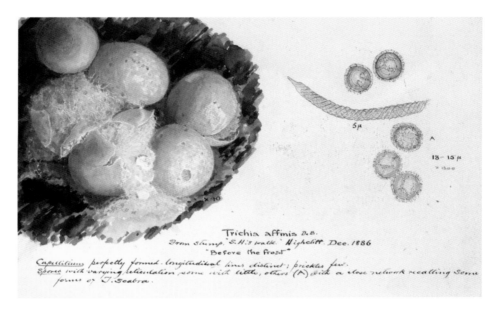

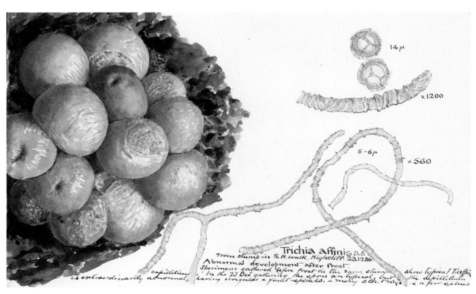

Trichia affinis (before and after frost), slime mould (Myxogastria, Amoebozoa)

Gulielma Lister was an expert in Myxogastria or slime moulds. She worked closely with her father and published many groundbreaking works on this group. Their classic *Monograph of the Mycetozoa* (1894) features many of her illustrations. Slime moulds are gigantic amoeba that slowly crawl through soils or on the trunks of trees hunting for their food that includes algae, fungi and bacteria.

Gulielma Lister (1860–1949)
Watercolour on paper
1886
166 x 263 mm and 156 x 255 mm

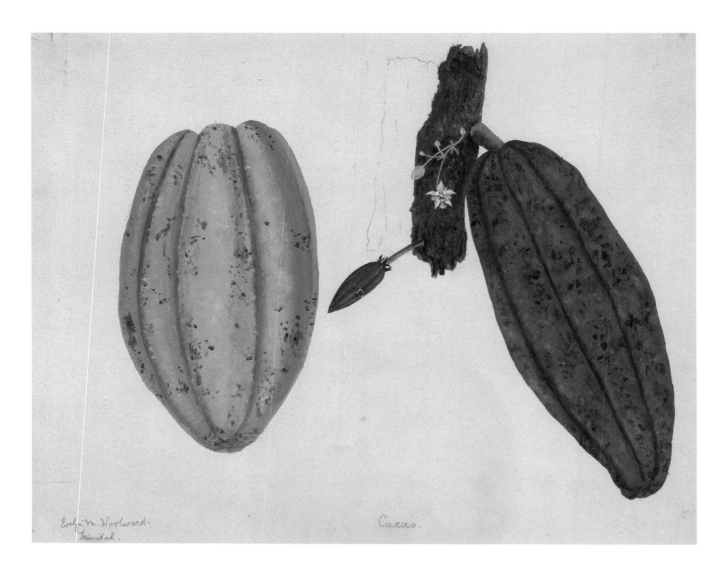

Theobroma cacao, cocoa tree

Evelyn M. Woolward's watercolours of flowers and fruits are from her travels to Barbados, Madeira, Guyana and Jamaica that she undertook at the end of the nineteenth century. The seeds of *Theobroma cacao* are the main ingredient of chocolate. There are three main cultivar groups of the cacao bean used to make chocolate and cocoa: Criollo, Foraster and Trinitario.

Evelyn M. Woolward (*fl*.1880–1890s)
Watercolour on paper
c.1887
255 x 341 mm

Lantana camara, Spanish flag

Adeline Frances Mary Duppa travelled round Europe with her husband and completed this particular drawing during a trip to Madeira in 1871. She added a curious shading effect to many of her drawings to give the plant subjects a shadow.

Adeline Frances Mary Duppa (1845–1895)
Watercolour on paper
1871
270 x 171 mm

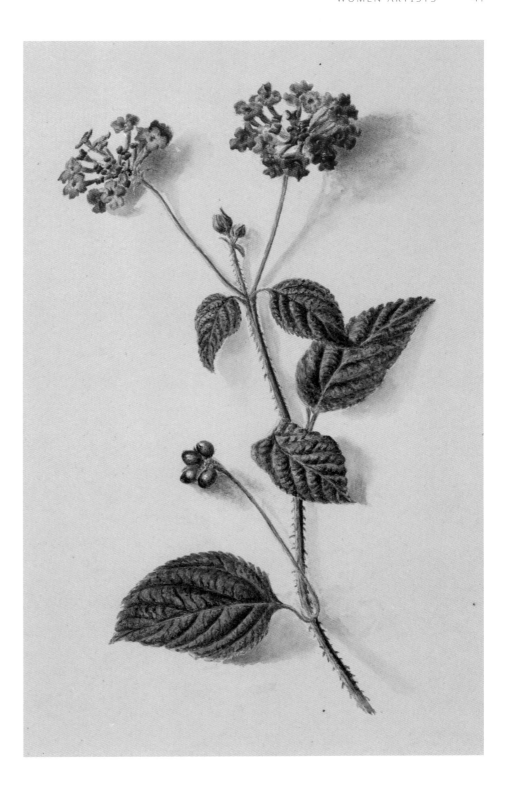

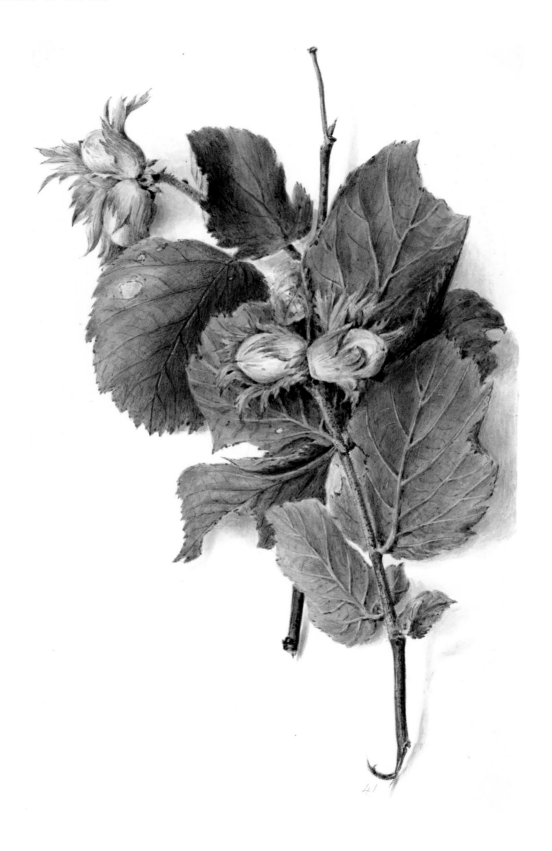

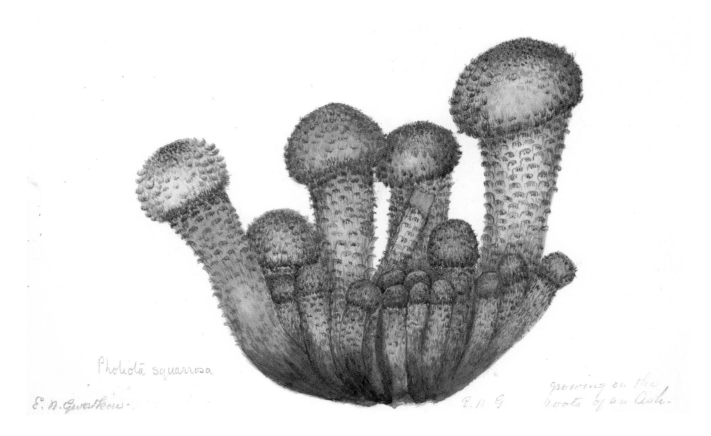

Pholiota squarrosa

E. N. Gwatkin.

E. N. G

growing on the roots of an Ash.

Corylus sp., hazel

This illustration comes from a collection of drawings of 261 British wildflowers that were presented to the Museum in 1983. The green leafy husk surrounding the hazelnut is called an involucre, the size and structure of which are important in the identification of the different species of hazel.

Laura Burrard (*c*. twentieth century)
Watercolour on paper
c. twentieth century
227 x 140 mm

Pholiota squarrosa, shaggy scalycap

Little is known about Miss E. N. Gwatkin who illustrated both flowers and fungi. The shaggy scalycap is a common mushroom in North America and Europe and is usually found growing in clusters at the base of trees and stumps. It is not an edible fungus and is considered poisonous.

Miss E. N. Gwatkin (*fl*.1908)
Watercolour on paper
c.1900
177 x 253 mm

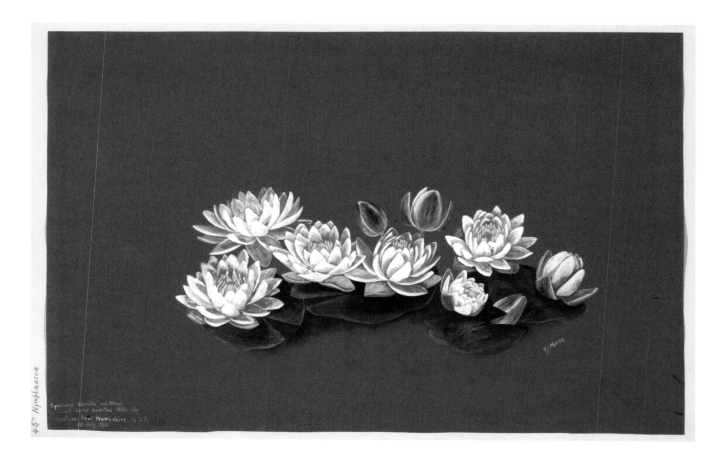

Nymphaea odorata, fragrant water lily

Mr Hosea B. Morse and his wife Annie were encouraged to pursue botanical collecting by Augustine Henry, a plantsman and sinologist who worked with Hosea for the Imperial Customs Service in China. In addition to her collection of North American wildflower drawings (above), Annie, or Mrs H. B. Morse as she signed her drawings, also completed illustrations of Chinese flora.

Mrs H. B. Morse (Annie Josephine Wexford) (1853–1940)
Watercolour on paper
1901
311 x 477 mm

Populus tremula subsp. *grandidentata*, common aspen

Florence Helen Woolward's illustrations of poplar and elm trees demonstrate her draughtsmanship and botanical expertise. By placing the catkins both behind and in front of the branch on this illustration, Woolward gives it a three-dimensional effect. This particular species is a deciduous tree native to eastern North America.

Florence Helen Woolward (1854–1936)
Watercolour on paper
1905
314 x 252 mm

P. grandidentata. 2. ♀

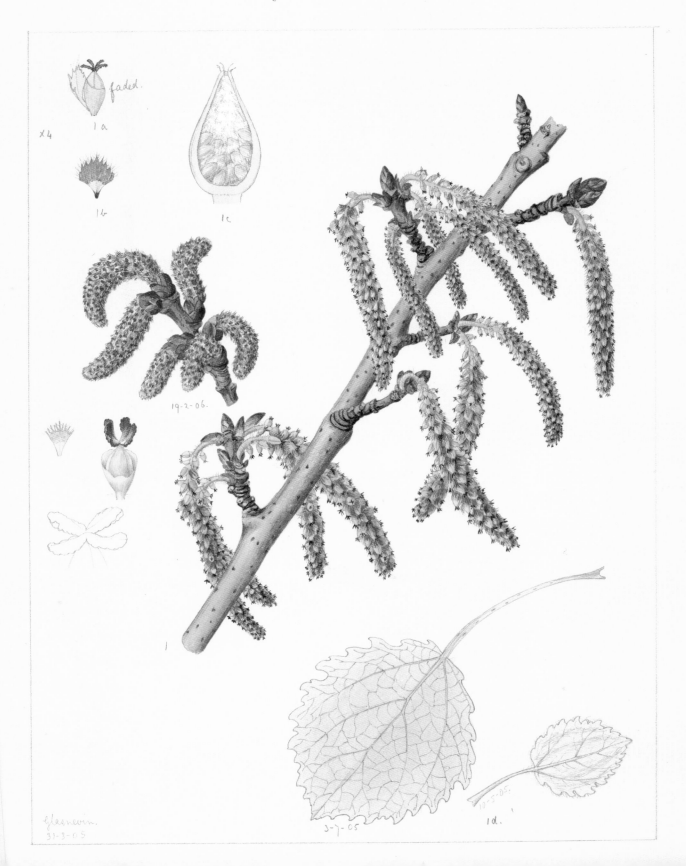

x4

1a faded.

1b

1c

19-2-06.

Glasnevin.
31-3-05

3-7-05 1d.

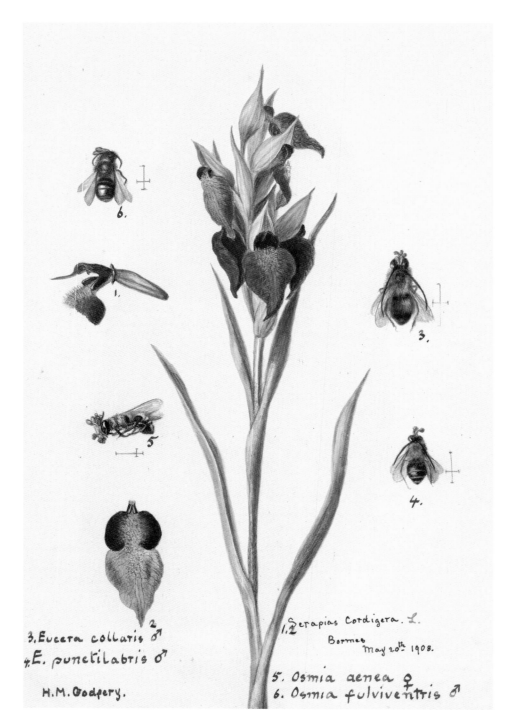

Serapias cordigera, orchid

Hilda Margaret Godfery specialised
in illustrating orchids and provided
all of the drawings for her husband's
comprehensive taxonomic work on
British Orchidaceae. The quality of her
illustrations led to her receiving a Royal
Horticultural Society Gold medal award
in 1925.

Hilda Margaret Godfery (1871–1930)
Watercolour on paper
1908
243 x 158 mm

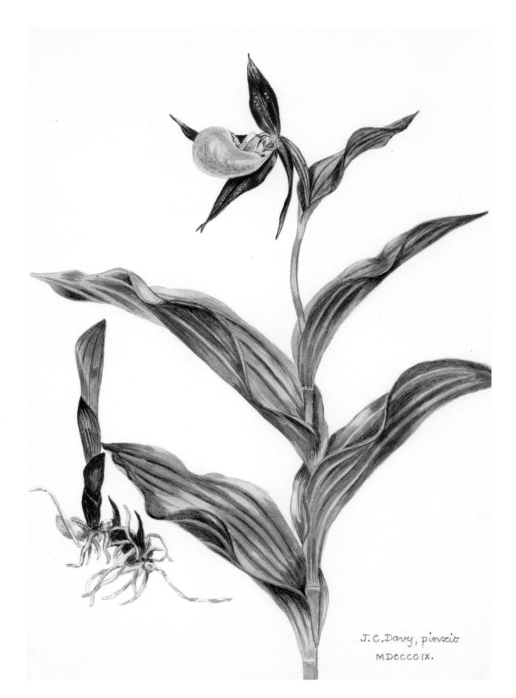

Cypripedium calceolus, lady's slipper orchid

Lady Joanna Charlotte Davy was a plant collector as well as an amateur botanical artist and it was through her collecting and illustration that she discovered a new species of sedge, *Carex microglochin*. Her illustrations of British Orchidaceae were completed over a six-year period from 1906 to 1912. This particular lady's slipper orchid came close to extinction in Great Britain prior to a reintroduction programme in 2003.

Lady Joanna Charlotte Davy
(née Flemmich) (1865–1955)
Watercolour on paper
1909
263 x 177 mm

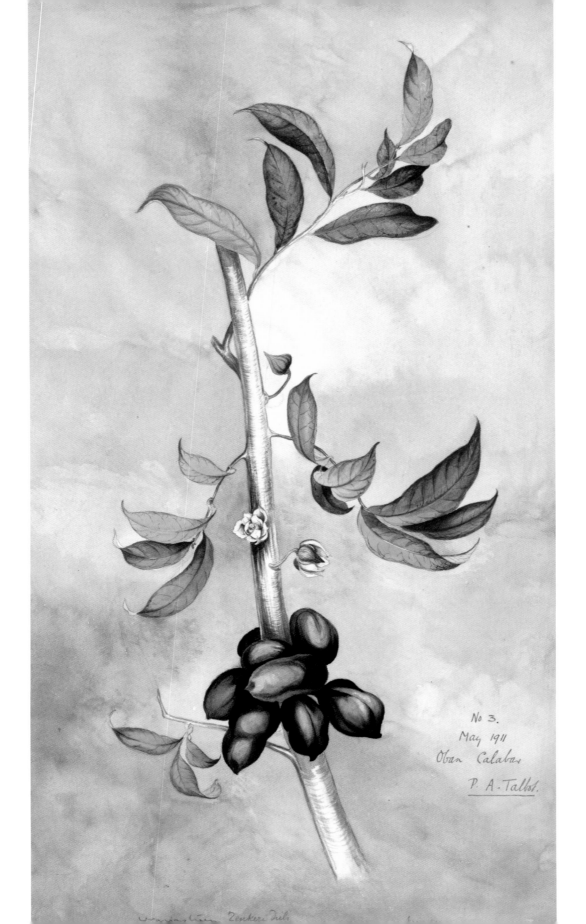

No 3.
May 1911
Oban Calabar

P. A. Talbot.

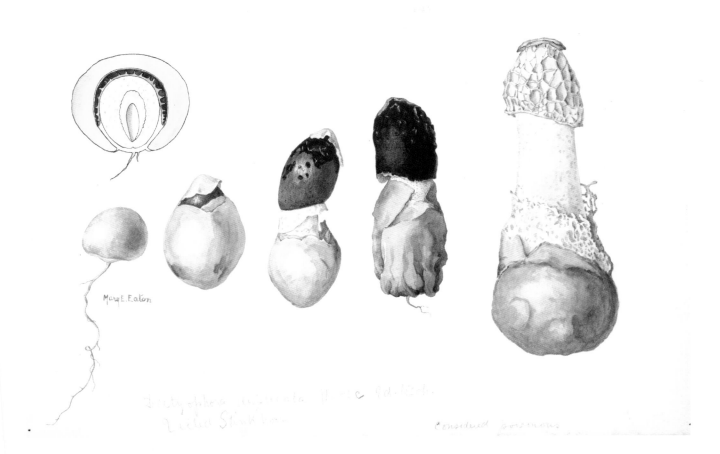

Uvariastrum zenkeri

Dorothy Talbot collected plants with her husband, Percy Amaury Talbot, in Nigeria from 1909 until her death in 1916. They are now part of the Herbarium collections at the Museum, along with nearly 600 of her drawings. Many of her drawings feature a wash background.

Dorothy Talbot (1871–1916)
Watercolour on paper
1911
684 x 386 mm

Phallus impudicus, veiled stinkhorn

Mary Eaton painted for Worcester porcelain before moving to the United States where she was employed as the principal artist at the New York Botanical Garden. Her delicate and scientifically accurate illustrations demonstrate her understanding of both flowering and non-flowering plants as well as the fungi, as shown in this drawing.

Mary Eaton (1873–1961)
Watercolour on paper
1912
250 x 340 mm

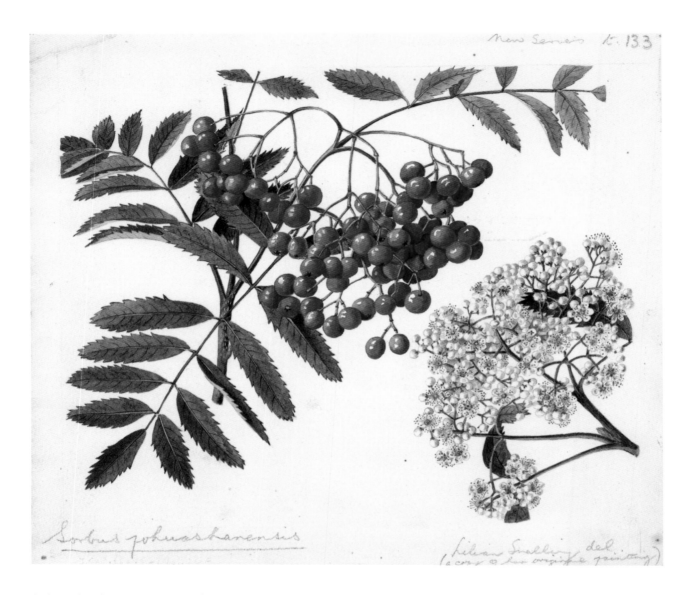

Sorbus pohuashanensis, mountain ash

Lilian Snelling was based at the Royal Botanic Gardens in Edinburgh and published in *Curtis's Botanical Magazine* over a 30-year period. The seeds of this *Sorbus* tree are thought to contain hydrogen cyanide which, if consumed in large quantities, can cause respiratory failure.

Lilian Snelling (1879–1972)
Watercolour on paper
c.1920s
246 x 284 mm

Juniperus communis, juniper

Beatrice Corfe was born and lived
in Winchester, England. The Library
holds over a 1,000 watercolours of
British plants and 89 pencil drawings
of flower sections that she completed.
Her clean lines, delicate use of colour
and understanding of the taxonomic
elements of each plant are ably
demonstrated in her stunning and
scientifically accurate illustrations.

Beatrice Corfe (1866–1947)
Watercolour on paper
*c.*1930
286 x 189 mm

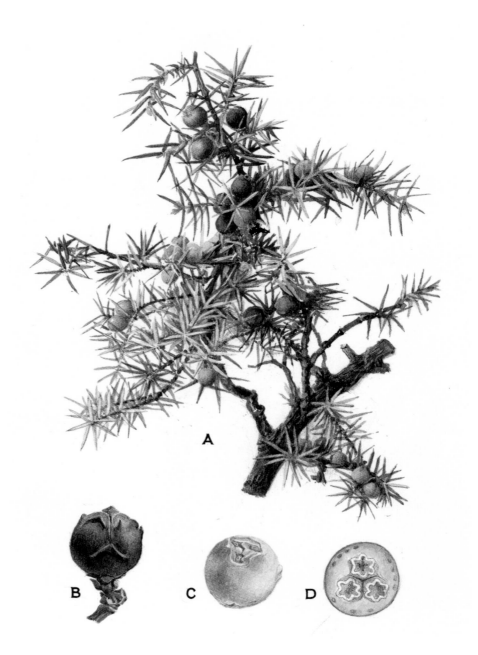

Bredia fordii

Stella Ross-Craig worked as a botanical illustrator and taxonomist at Kew Gardens and contributed illustrations to *Curtis's Botanical Magazine* over a period of nearly 50 years. She often drew from herbarium specimens and much of her work was pen and ink line drawings, of which over 1,300 featured in her monumental *Drawings of British Plants* series (1948–1973).

Stella Ross-Craig (1906–2006)
Watercolour on paper
*c.*1940s
252 x 170 mm

Phyllocactus crenatus, crenate orchid cactus

Hilda Maud Coley illustrated popular botanical books on fruits and flowers. Her use of ink wash provides a dramatic black and white effect on this orchid cactus. The ink wash technique is similar to watercolour painting – thinning the ink with water provides lighter values of colour.

Hilda Maud Coley (*fl.*1937–1950s)
Ink wash on card
*c.*1950s
386 x 315 mm

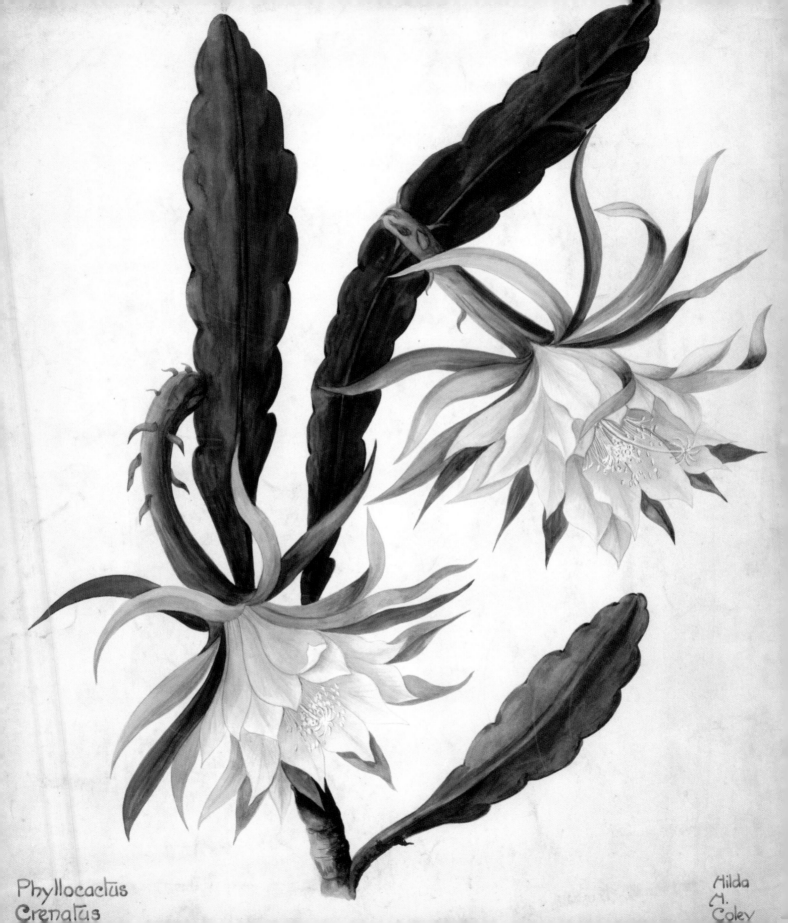

Phyllocactus
Crenatus

Hilda
M.
Coley

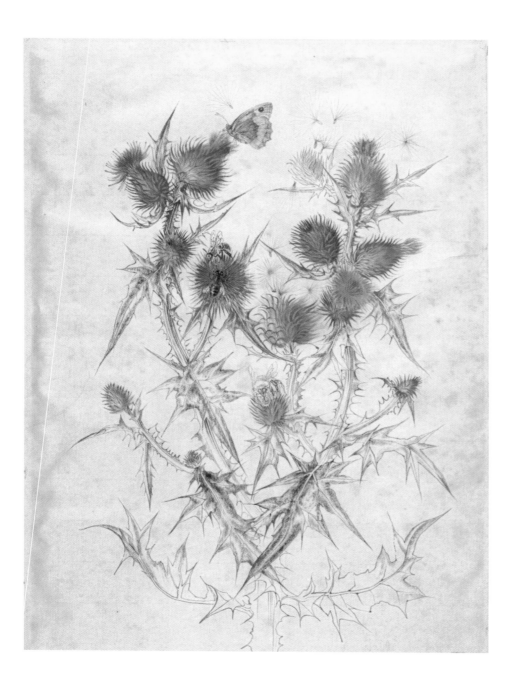

Cirsium vulgare, spear plume thistle

Vere Lucy Temple was a natural history artist who not only wrote and illustrated many entomological books, but also Enid Blyton's *Hedgerow Tales* (1935). The spear thistle is generally regarded as a weed. A self-fertile plant, its flowers provide a rich nectar source for pollinating insects, including bees and butterflies.

Vere Lucy Temple (1898–1980)
Watercolour and ink on paper
c.1950s
457 x 340 mm

Bromelia anticantha, bromeliad

Margaret Mee undertook many expeditions to the Amazon where she campaigned against the deforestation and environmental damage taking place. She painted almost entirely from living plants, which she would sketch in pencil and then paint with bodycolour or watercolour.

Margaret Mee (1909–1988)
Watercolour on paper
1958
660 x 480 mm

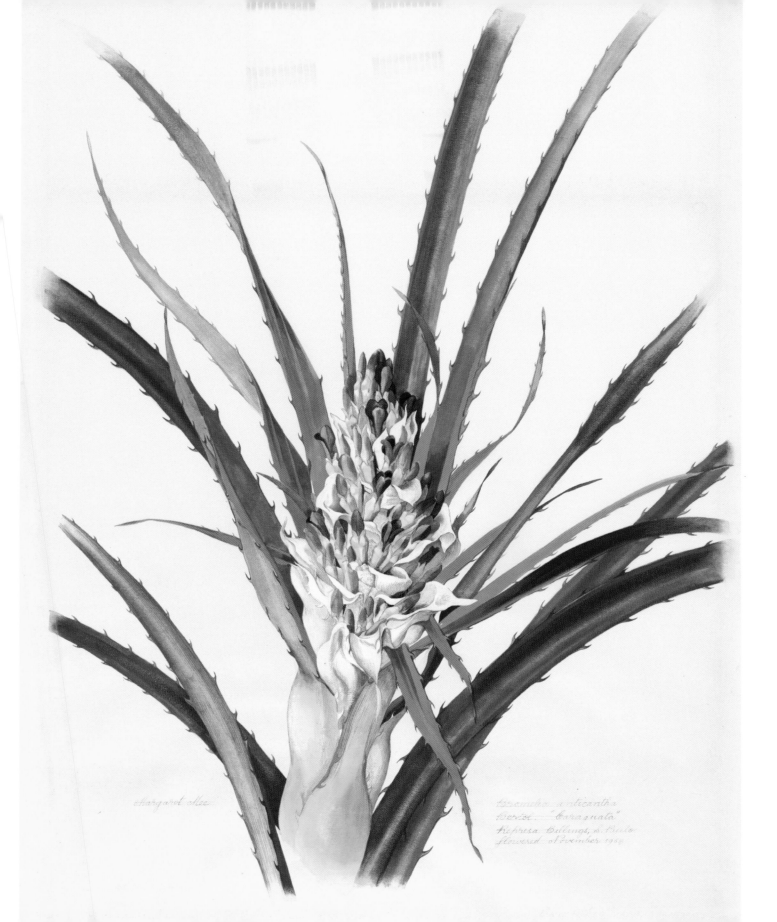

margaret mee

taxonomic anticantha
Merioc "Caraguata"
Represa Billings, S. Paulo
flowered November 1968

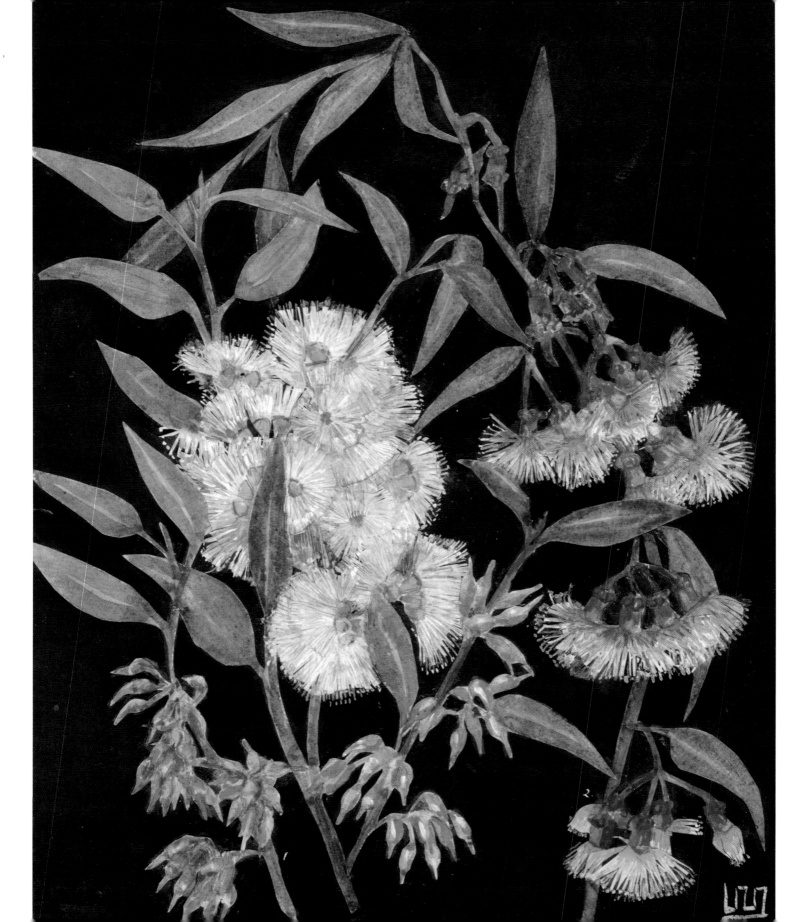

Eucalyptus oleosa, red mallee,
Eucalyptus torquata, coral gum

This artwork is from a collection of 71
watercolour paper mosaics of Western
Australian plants. They are after the style
and in tribute to the artist Mrs Mary
Delany (1700–1788) who created over
a thousand scientifically accurate paper
mosaics.

Lorna Maitland (*fl.*1960s)
Mixed materials: watercolour on paper
glued on card
1959–1960
316 x 253 mm

Taraxacum officianale, dandelion

Winifred Bussey studied art at
Goldsmith's College in London but did
not begin her drawings of British flora
until she was 71. The Museum held a
temporary exhibition of her work in
the former Botany Gallery in 1971. The
dandelion is a prolific producer of seeds
and is illustrated here in both its seed
and flowering stages.

Winifred Bussey (1884–1969)
Watercolour on paper
*c.*1959
292 x 230 mm

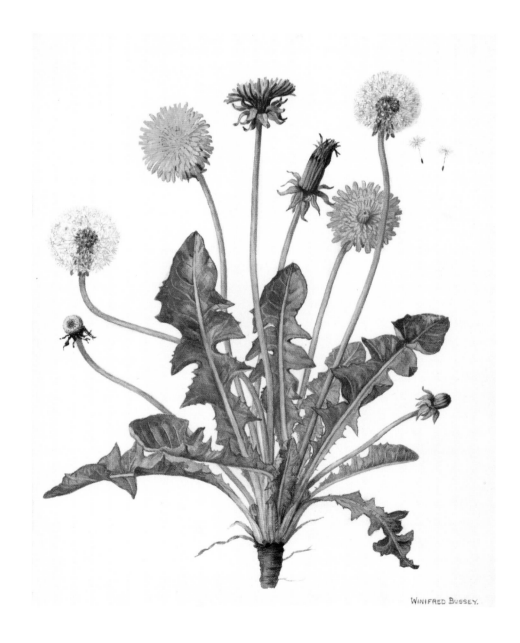

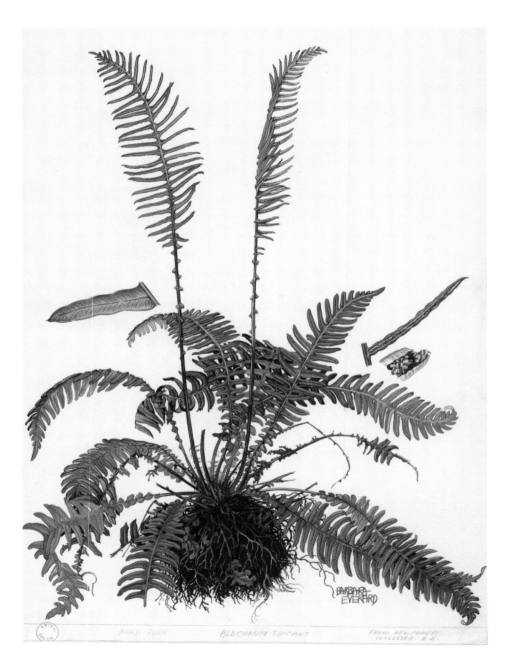

Blechnum spicant, hard fern

Barbara Everard is one of the twentieth century's leading botanical artists. She initially worked at a fake antiques business before going to live in Singapore with her husband, where she both collected and painted plants. They returned to England in 1952 where she excelled as a commercial botanical artist and undertook many private commissions.

Barbara Everard (1910–1990)
Watercolour on paper
c.1970
540 x 385 mm

Orobanche crenata, bean broomrape

Regarded as one of the world's most distinguished botanical artists, Mary Grierson's illustrations are meticulously accurate in detail. Bean broomrape is a root parasite that has devastating effects on vegetable production.

Mary Grierson (1912–2012)
Watercolour and graphite on paper
1970
576 x 390 mm

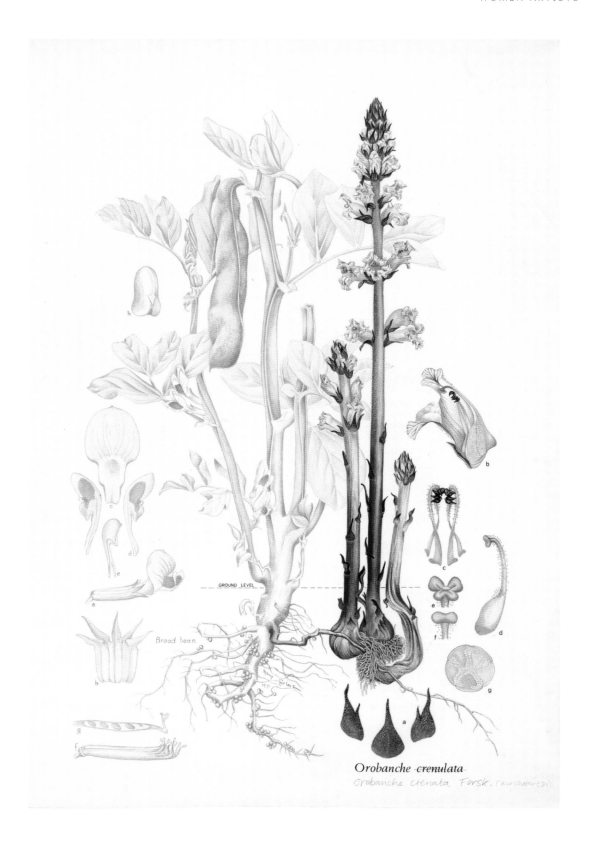

Orobanche crenulata
Orobanche crenata Forsk. (*...*)

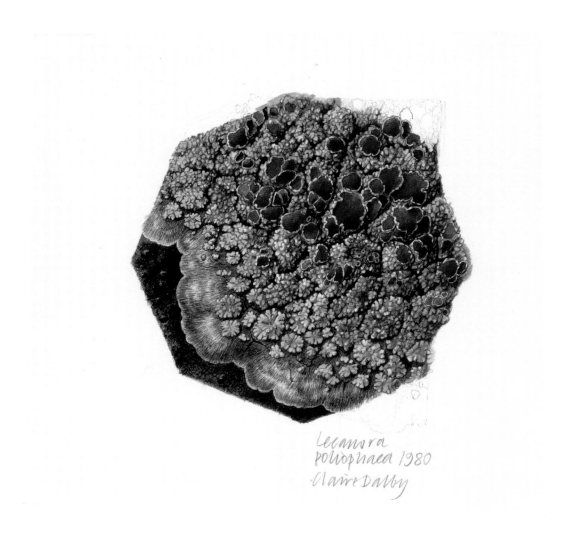

*Lecanora
poliophaea 1980
Claire Dalby*

Lecanora poliophaea, lichen

Born in Fife, Claire Dalby paints landscapes and still life as well as plant portraits and scientific studies. Her artistic interests are in forms, textures and colours. She skilfully uses light and shade to demonstrate the structure and appearance of her subjects. This lichen has a growth form that is crustose, which means it attaches itself tightly to the rocks where it is found.

Claire Dalby (b.1944)
Watercolour on paper
1980
189 x 195 mm

Rhododendron eclecteum, rhododendron

Elizabeth Cameron had a successful career as a frozen food entrepreneur before taking up watercolour painting. Inspired by the famous Scottish gardens Brodick, Glenarn and Inverewe as well as her home garden Allangrange, her work won her six medals from the Royal Horticultural Society. In 2006 she published *A Book of Rhododendrons* that featured 25 of her illustrations.

Elizabeth Cameron (1915–2008)
Watercolour on paper
1981
481 x 390 mm

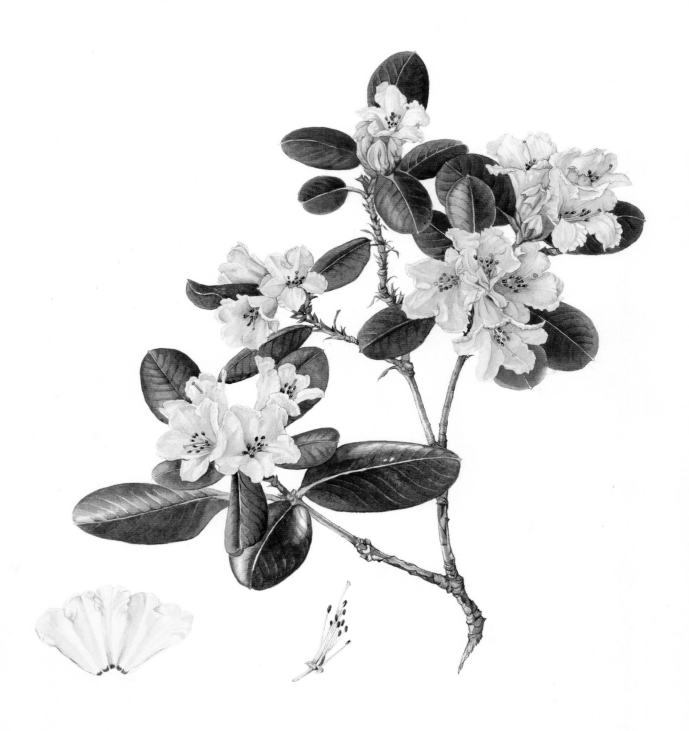

Rhododendron eclecteum
Glendoick

EC. 1981

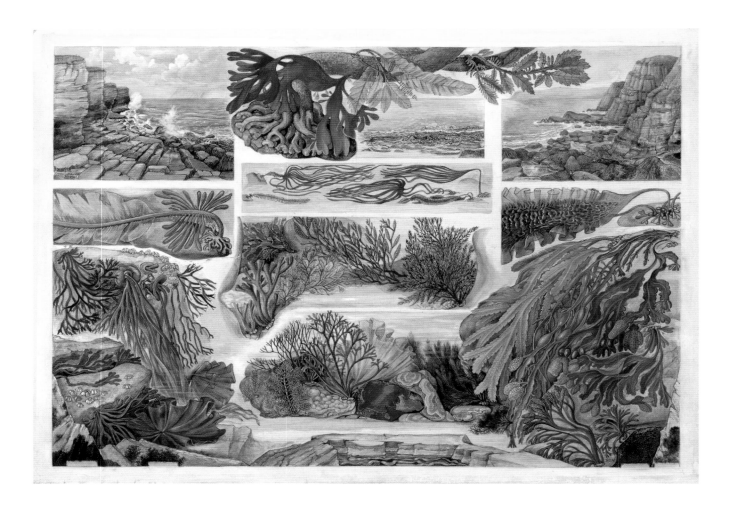

Various British seaweeds

Barbara Nicholson illustrated a number of botanical books. Her educational posters, commissioned by the Museum, featured a diverse range of British ecological communities. These were informative, incredibly popular and, most importantly, were scientifically accurate.

Barbara Nicholson (1906–1978)
Watercolour on board
c.1970–1977
490 x 700 mm

Helianthus tuberosus

Margaret Stones not only has the ability to give her botanical drawings aesthetic and pictorial content but, most crucially for contemporary botanical illustration, complete accuracy of form, growth, colour and shape. The hairy sunflower is part of the Asteraceae family and bears masses of wonderful lemon-yellow flowers.

Margaret Stones (b.1920)
Watercolour on paper
1982
571 x 384 mm

Begonia luxurians, palm leaf begonia

Jenny Brasier has been awarded
numerous Royal Horticultural Society
gold medals for her work on both
paper and vellum. A founder member
of the Society of Botanical Artists,
she attributes her artistic talent to her
grandfather. *Begonia luxurians* are found
in the rainforests of Brazil. Their distinct,
large palmate leaves with red centres
give the plant a very exotic appearance.

Jenny Brasier (b.1936)
Graphite on paper
1982
780 x 580 mm

Musa acuminata subsp. *acuminate*,
banana

Toni Hayden is a contemporary botanical
artist and skilled calligrapher. She uses a
variety of techniques and media for her
artwork that is not restricted to flora.
She teaches portraiture, life drawing
and flower painting. The *Musa* genus
includes bananas and plantains. Around
70 species have been recognised with
several producing edible fruit and others
cultivated as ornamentals.

Toni Hayden (b.1938)
Coloured pencil on paper
1982
695 x 460 mm

Tolpis farinulosa

Margaret Tebbs is a highly regarded international artist and she has contributed artwork to many scientific taxonomic publications. She worked as a curator and taxonomist at the Natural History Museum before becoming a freelance botanical illustrator at the Royal Botanic Gardens, Kew.

Margaret Tebbs (b.1948)
Ink on card
1984
387 x 317 mm

Paphiopedilum spicerianum, lady's slipper orchid, *Maranta* sp., prayer plant, *Philodendron* sp.,

Pandora Sellars initially trained as a textile designer before becoming a freelance illustrator, specialising in painting orchids. This watercolour is a species of orchid originally from India that was first scientifically described in 1880.

Pandora Sellars (b.1936)
Watercolour on paper
1985
483 x 334 mm

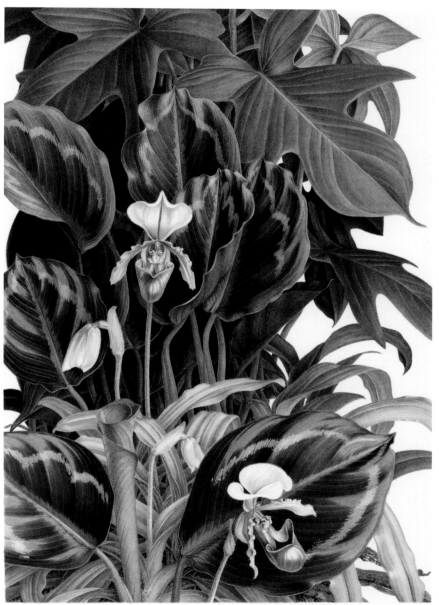

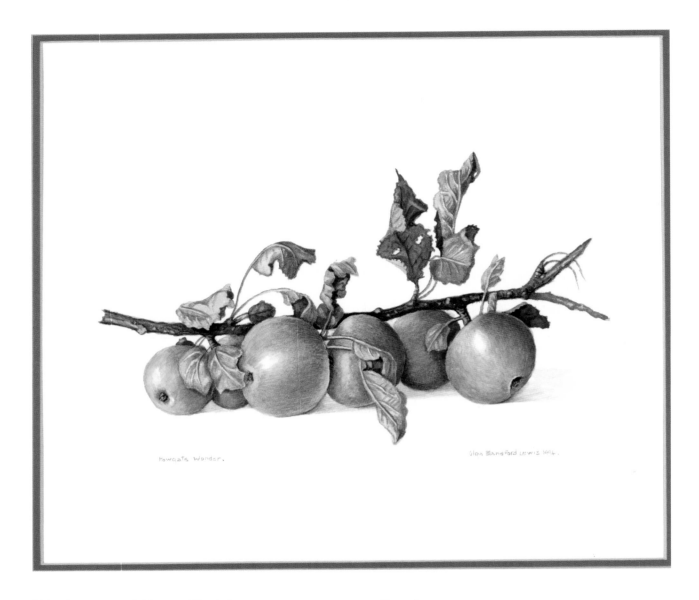

Malus domestica, apple 'Howgate Wonder'

Olga Blandford Lewis was the daughter of a Greek naval architect. She worked as a Red Cross nurse at the Harold Wood Hospital, Romford throughout the Blitz. Originally a medical artist, she did not take up botanical illustration seriously until later in life. Her drawings collection consists of orchard fruits and cultivated orchids.

Olga Blandford Lewis (1917–2002)
Watercolour on paper
1994
405 x 507 mm

Magnolia sp.

Olga Makrushenko is a freelance botanical artist who lives in Moscow. Her use of mixed media and airbrush overlay techniques enables her to achieve stunning results with both botanical and zoological subjects.

Olga Makrushenko (b.1957)
Mixed media on card
1999
350 x 250 mm

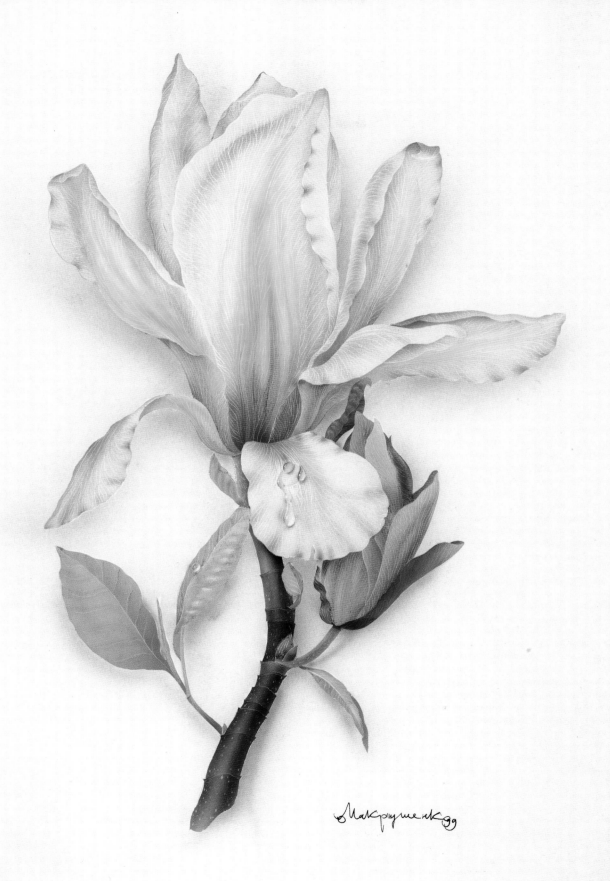

Макрушенко 99

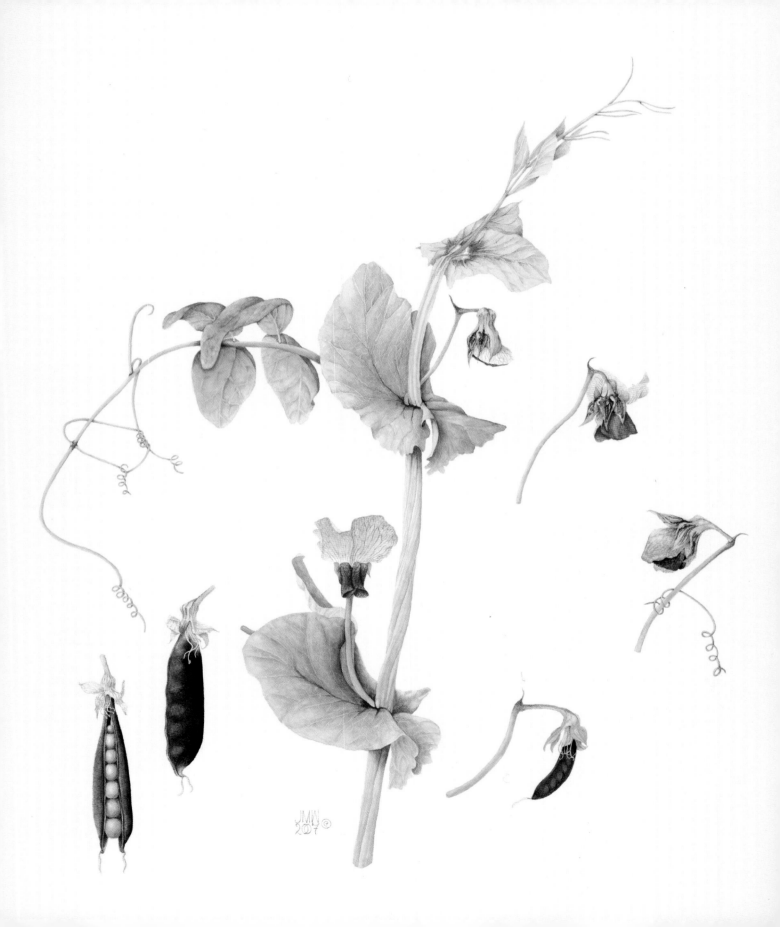

Pisum sativum, pea 'Commander'

Jean Webb grew the peas featured in her *Heritage Peas Series* of watercolours over a period of two years. Heritage peas are usually of taller habit than modern garden peas but rely on propagation and seed collection to continue to exist. The pea 'Commander' variety can grow to a height of seven feet (2.1 metres) and its beautiful purple pods, as depicted in this illustration, are packed full of green peas that are suitable for cooking or drying.

Jean Webb (b.1943)
Watercolour on card
2007
545 x 380 mm

Swetenia sp., mahogany leaves and seed pods

Jessica Tcherepnine is a respected contemporary botanical artist whose work has been widely exhibited for the past 30 years. A self-taught artist, she is a founding member of the American Society of Botanical Artists. This illustration of mahogany leaves and seeds, a recent donation to the Museum's collections, demonstrates her meticulous attention to detail and is another example of her distinctively timeless work.

Jessica Tcherepnine (b.1938)
Watercolour on paper
2010
455 x 583 mm

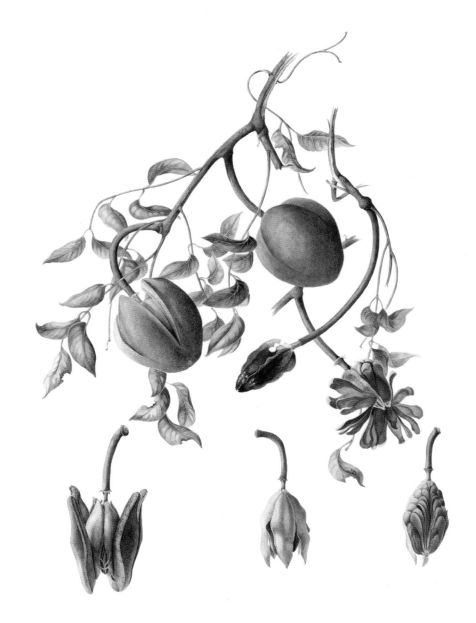

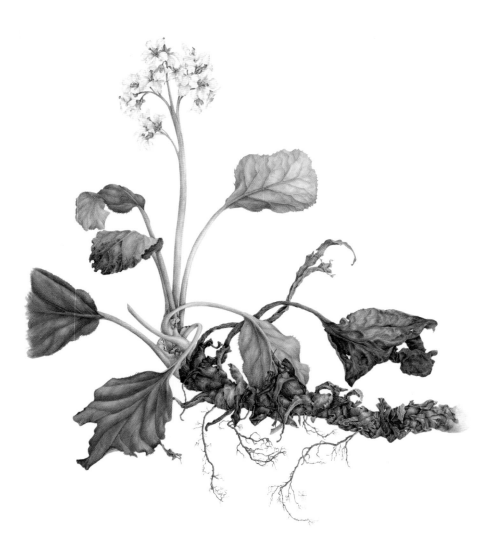

Bergenia cordifolia, elephant-eared saxifrage

Norma Gregory is an accomplished contemporary botanical artist with an accurate eye for detail and colour. Preventing the *Bergenia* specimen from drying out before she could paint it proved challenging – the leaves and flowers had to be misted constantly to stop them from going limp.

Norma Gregory (b.1942)
Watercolour on card
2011
625 x 488 mm

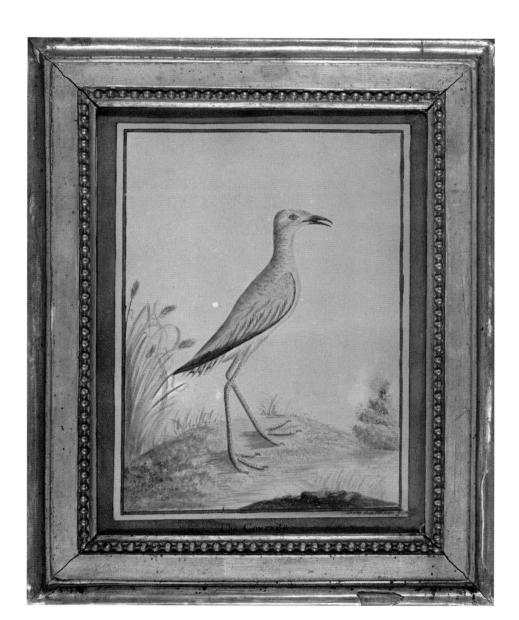

Cursorius cursor, cream-coloured courser (juvenile)

This painting is of the first specimen of the cream-coloured courser bird that was shot by John Hammond near Wingham, Kent, on 10th November 1785. The bird was exhibited in the Leverian Museum in London, the large natural history and ethnographic collection assembled by Ashton Lever that closed in 1806. It is not known how Ann Latham came to paint this bird.

Ann Latham (1772 to after 1837)
Watercolour on paper
Late 1780s
210 x 157 mm

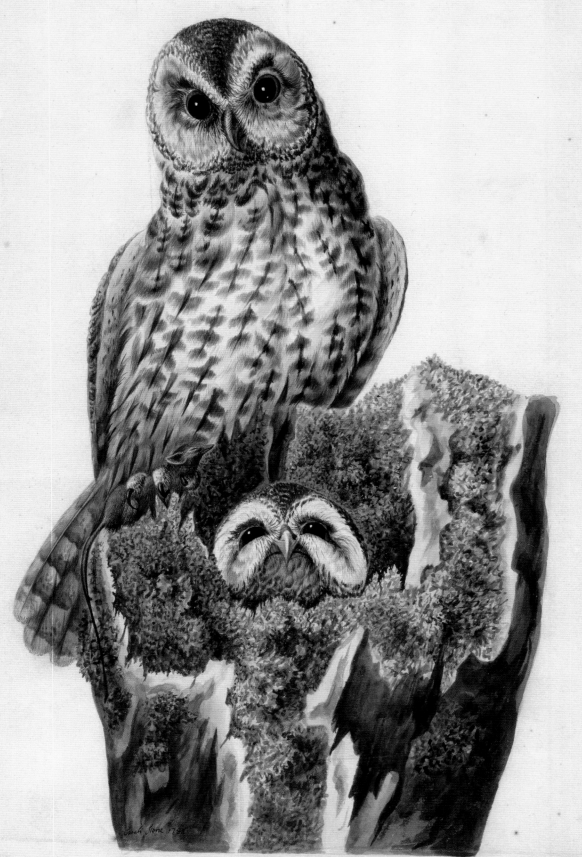

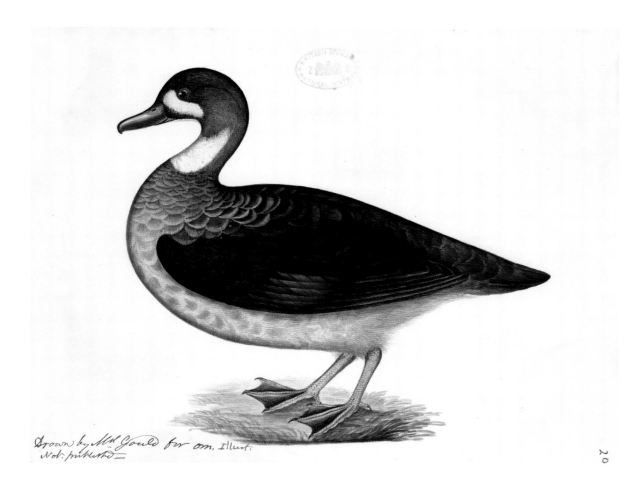

Strix aluco, tawny owl

Sarah Stone's drawings are thought to be the only surviving evidence of specimens, once held in Sir Ashton Lever's Leverian Museum, that were sold off by auction in 1806. The tawny owl is a highly territorial bird that is commonly found across Eurasia. The species was first described by Linnaeus in 1758.

Sarah Stone (*c.*1760–1844)
Watercolour on paper
*c.*1788
472 x 422 mm

Anas specularis, bronze-winged duck

Elizabeth Gould assisted her husband, the renowned ornithologist John Gould, with the illustrations for many of his published books on birds. It was her husband's identification of Darwin's finches that played a key role in Darwin formulating his theory of evolution by natural selection. This drawing of a bronze-winged duck forms part of a collection of watercolour drawings and sketches of birds that belonged to the influential Scottish naturalist Sir William Jardine (1800–1874).

Elizabeth Gould (1804–1841)
Watercolour on paper
*c.*1830–1840
220 x 278 mm

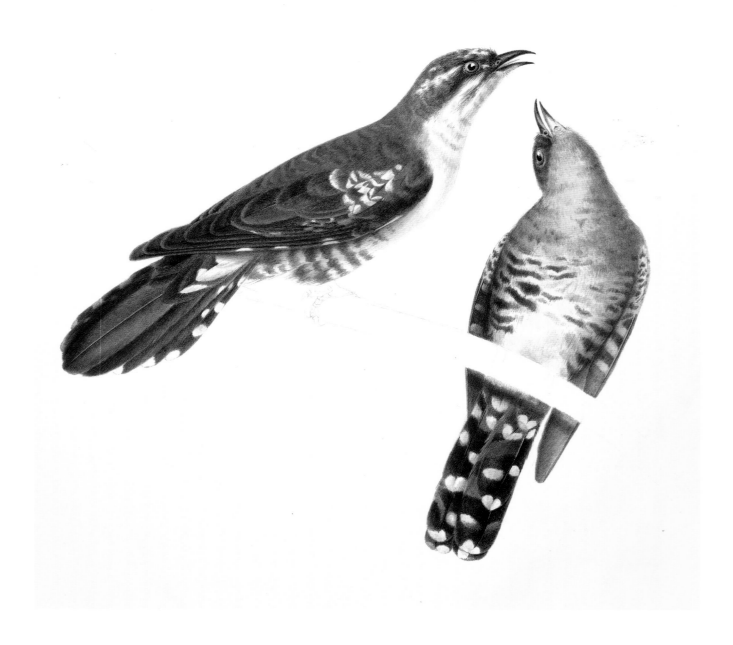

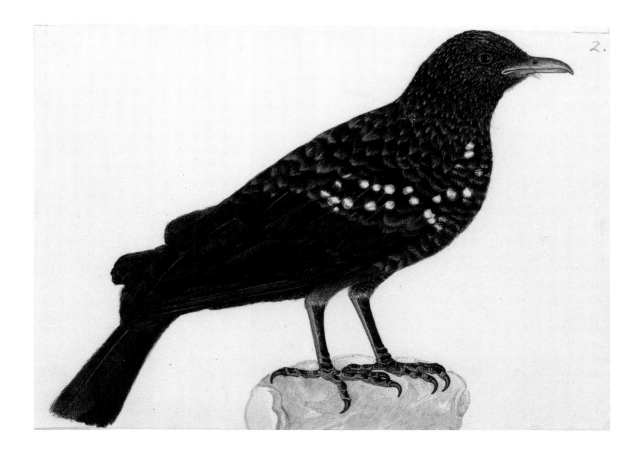

Chrysococcyx caprius, Diederik cuckoo

Mrs Susan Catherine Fenwick was a Scottish amateur artist. She produced four drawings of birds native to Tobago for her friend and neighbour Sir William Jardine. Similar to other cuckoos, the Diederik cuckoo is a brood parasite and lays a single egg in the nests of other species. It gets its name from its loud and persistent deed-deed-deed-deed-er-ick call.

Mrs Susan Catherine Fenwick (née Murray) (1810–1891)
Watercolour on paper
c. mid-nineteenth century
334 x 265 mm

Myophonus caeruleus, blue whistling thrush

Lady Mary Bentinck was the wife of Lord William Henry Cavendish-Bentinck who served as Governor General of India from 1828–1835. This drawing of the blue whistling thrush, which is found throughout the mountains of southern Asia, is from a volume containing over 60 drawings of Himalayan birds that it is believed she completed in 1833.

Lady Mary Bentinck (née Lady Margaret Cavendish Harley) (?–1843)
Watercolour on paper
1833
150 x 211 mm

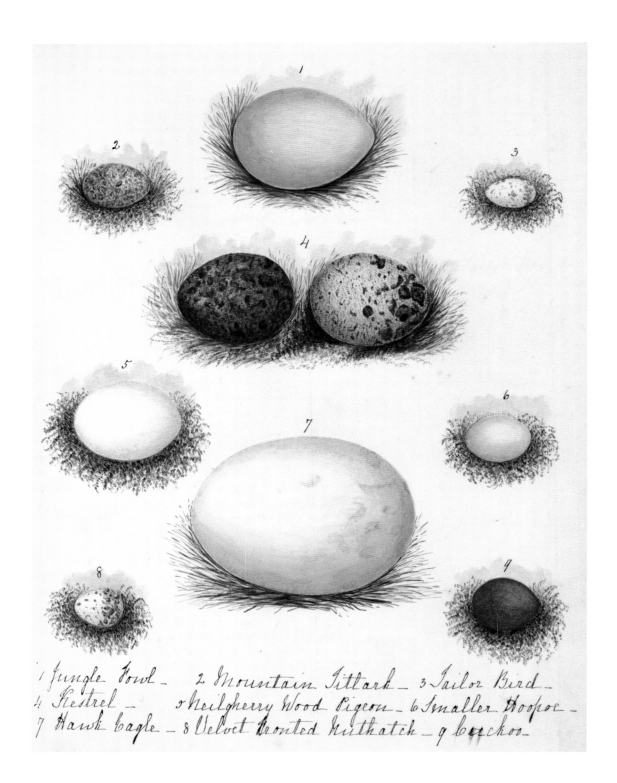

1 Jungle Fowl _ 2 Mountain Tittark _ 3 Tailor Bird _
4 Kestrel _ 5 Neilgherry Wood Pigeon _ 6 Smaller Hoopoe _
7 Hawk Eagle _ 8 Velvet fronted Nuthatch _ 9 Cuckoo _

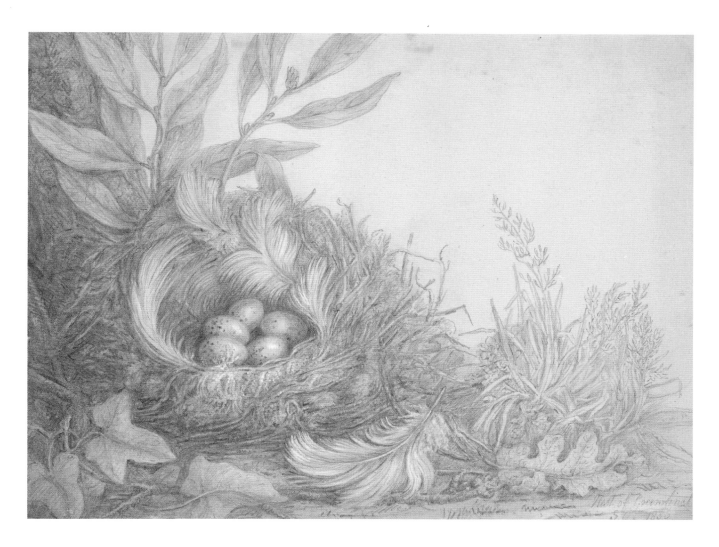

Various birds' eggs

Born in India, Margaret Bushby Lascelles Cockburn lived in the Nilgiris where she made notes and observations of the natural history and painted the local flora and fauna. An amateur ornithologist, she corresponded with the notable naturalist Allan Octavian Hume. Although a visually pleasing illustration, it is very difficult to identify eggs reliably from such drawings, especially as some of the common names she has given are now obsolete.

Margaret Bushby Lascelles Cockburn (1829–1928)
Watercolour on card
1858
260 x 223 mm

Nest of greenfinch

An exceptional artist, Sarah Ormerod home-schooled all of her 10 children. Her graphite drawings on coloured paper are both exquisite and unique to the Library's collections.

Sarah Ormerod (1784–1860)
Graphite and white paint on paper
1856
200 x 262 mm

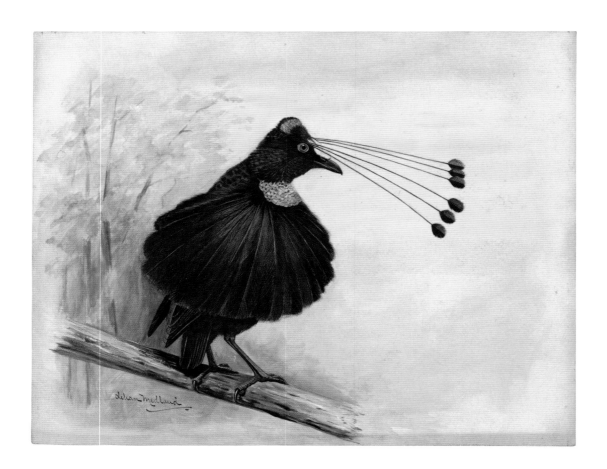

Parotia lawesii, Lawe's parotia

As a young girl, Lilian Medland reared animals, including two lion cubs, before training to be a nurse. A prolific bird painter, she contributed to many publications, including her husband Tom Iredale's *Birds of Paradise and Bower Birds* (1950) and *Birds of New Guinea* (1956). Lawes's parotia, endemic to Papua New Guinea, performs a colourful courtship routine to attract females.

Lilian Medland (1880–1955)
Watercolour on board
1909
230 x 292 mm

Aptenodytes forsteri, emperor penguin (embryo)

One of the beautiful graphite drawings of emperor penguin embryos from the three eggs that were collected by Edward Wilson, Henry Robertson Bowers and Apsley Cherry-Garrard in 1911 on the *Terra Nova* expedition, the scientific work of which helped lay the foundations for Antarctic science. A fisheries scientist, Dorothy Elizabeth Thursby-Pelham worked with animal embryologist Dr Assheton on the special task of analysing the embryos.

Dorothy Elizabeth Thursby-Pelham (1884–1972)
Graphite on paper
*c.*1914–1915
268 x 199 mm

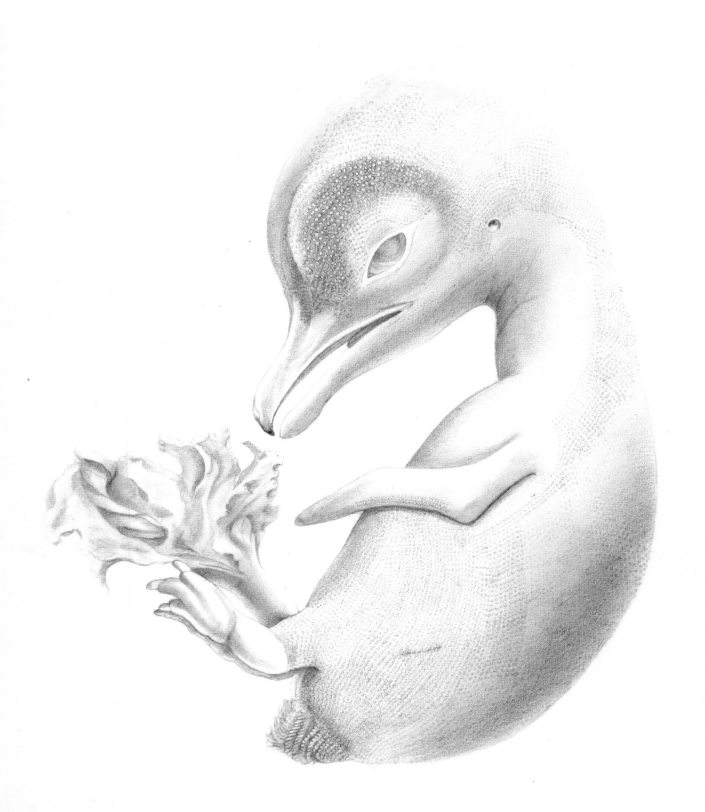

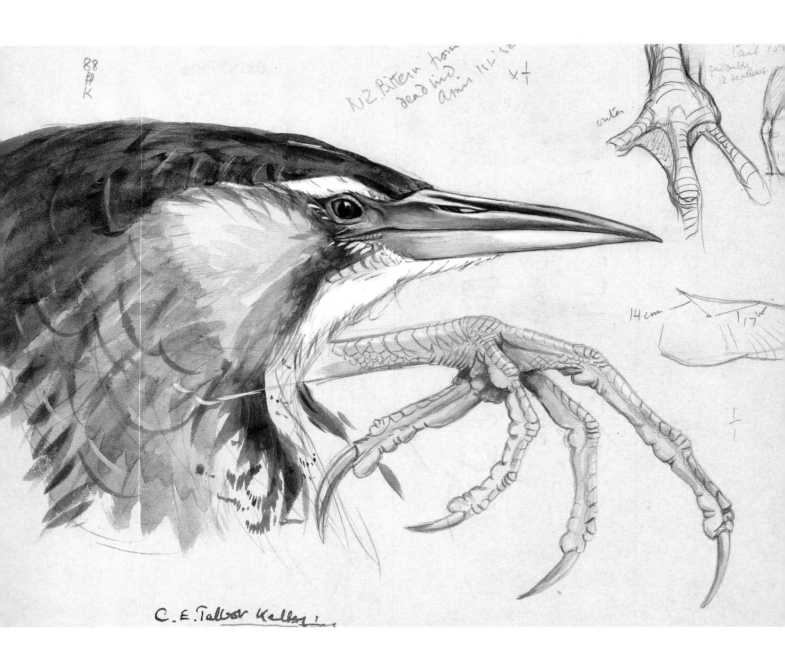

88
K

N.Z.Bittern from
dead ind.
army 16.v.58
x⅓

outer

tail 15"
probably
12 feathers

14cm
17"

C.E.Talbot Kelly

Botaurus poicilopterus, Australasian bittern

Chloe Talbot-Kelly is an internationally renowned ornithological artist who has illustrated numerous bird books whilst also publishing her own on the birds of New Zealand. A self-taught artist she followed in the footsteps of her father who also painted birds.

Chloe Talbot-Kelly (b.1927)
Watercolour on paper
1958
190 x 257 mm

Fratercula arctica, Atlantic puffin

Born in Canterbury, New Zealand, Muriel Helen Dawson came to England in 1913. After studying art, she established herself as a children's book illustrator. In the late 1950s she moved to the Shetland Islands where she sketched and painted birds, mammals and landscapes. A combination of colour, bodycolour and ink help to accentuate the recognisable features of the puffin – its colourful beak, black and white plummage and bright orange feet.

Muriel Helen Dawson (1897–1974)
Watercolour and pen on paper
1968
362 x 260 mm

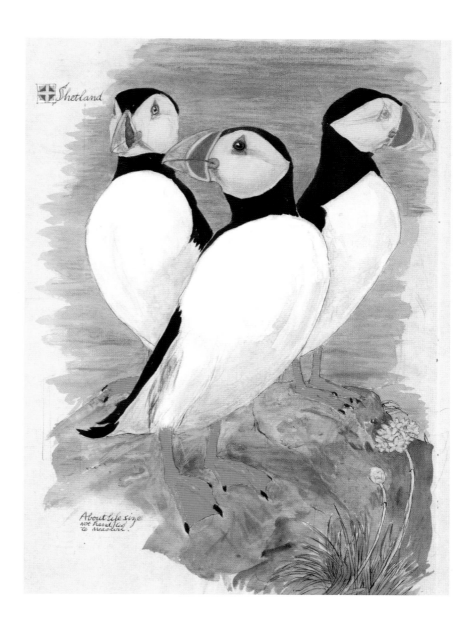

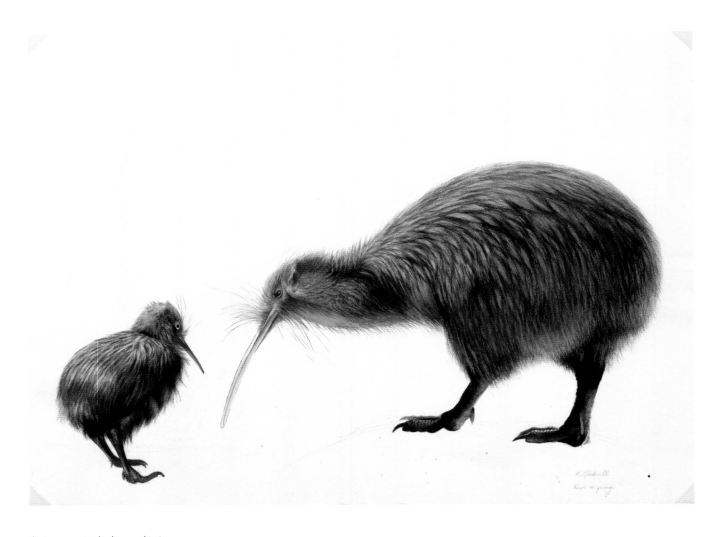

Apteryx australis, brown kiwi

Angela Gladwell has held a life-long fascination with natural history.
Her paintings cover a wide range of interests including museum
artefacts and costumes, landscapes, buildings and still life. There are
five known species of kiwi, all of which are endemic to New Zealand.

Angela Gladwell (b.1945)
Watercolour on paper
1997
570 x 763 mm

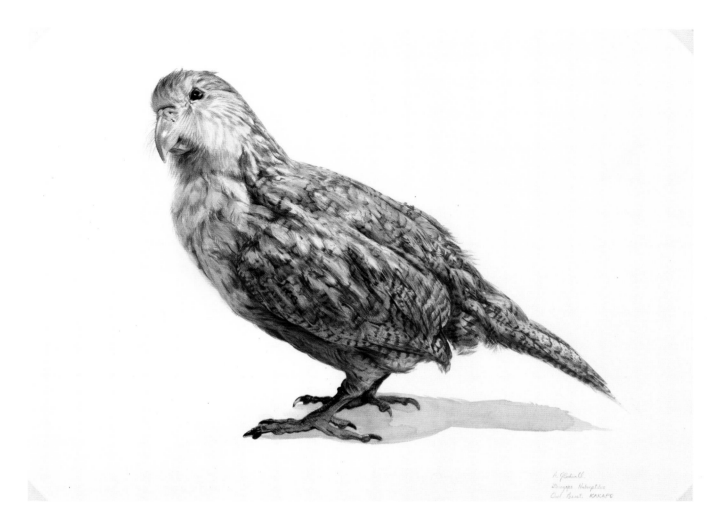

Strigops habroptilus, kakapo or owl parrot

Angela Gladwell's second bird illustration is of a kakapo, which is
the only species of flightless parrot in the world. Endemic to New
Zealand, it is a very good climber and has one of the longest life
expectancies of any bird – around 80 to 100 years.

Angela Gladwell (b.1945)
Watercolour on paper
1998
570 x 770 mm

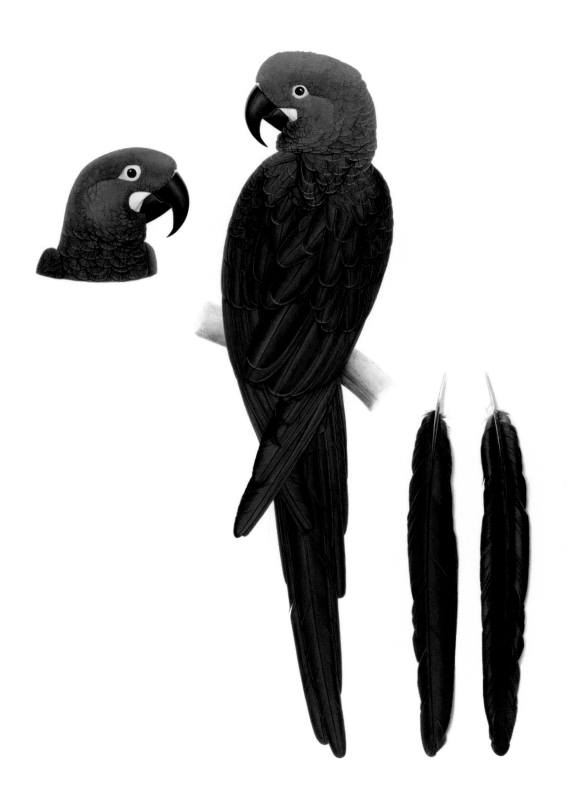

Anodorhynchus leari, Lear's macaw

The skill and detail evident in Elizabeth Butterworth's ornithological paintings is unrivalled, especially with her macaws. She is considered on a par with that of Edward Lear. Her knowledge of birds through their breeding and the study of skins in Museum collections has enabled her to become a bird expert in her own right. Her vivid use of colour and ability to depict the details and texture of feathers and plumage of her subjects is quite simply stunning.

Elizabeth Butterworth (b.1949)
Pencil, ink and bodycolour on paper
2005
767 x 570 mm

Cacatua galerita triton, sulphur-crested cockatoo

Rebecca Jewell bases her drawings around museum artefacts and the natural world. She is currently the artist in residence at the British Museum, Department of Africa, Oceania and the Americas (AOA). This drawing is based on the bird skin specimens held in the Museum's collections at Tring.

Rebecca Jewell (b.1963)
Watercolour on paper
2002
565 x 380 mm

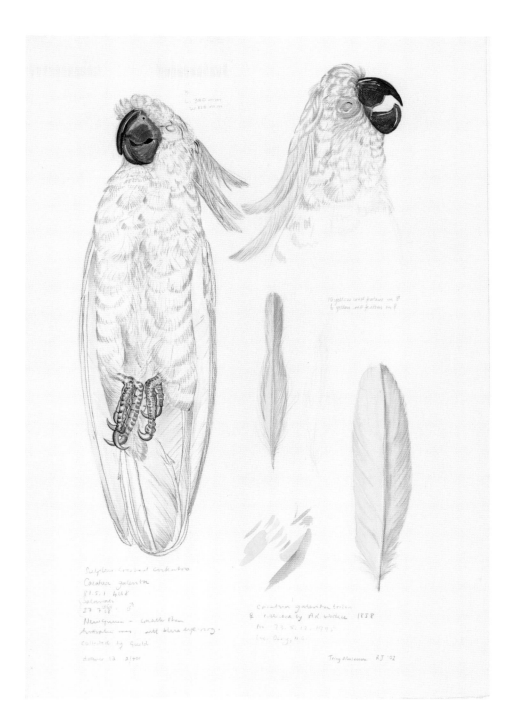

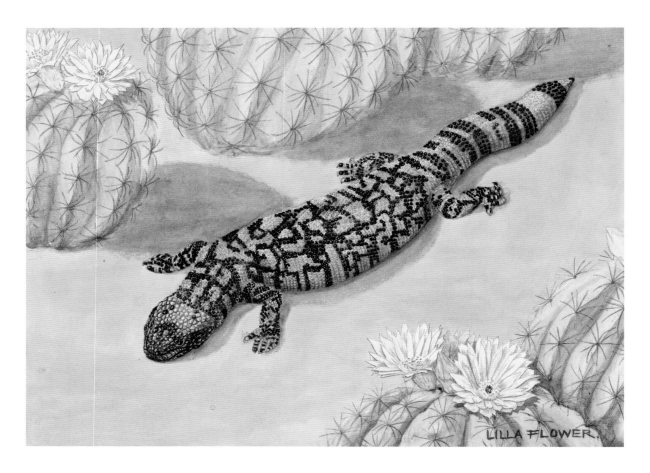

Heloderma suspectum, gila monster

No information about the artist is known. The gila monster is the only venomous lizard native to the United States. As it is slow in its movement, however, it does not represent a threat to humans. It spends most of its time underground in burrows and is preyed upon by coyotes and raptors.

Lilla Flower (dates unknown)
Watercolour on board
c. first half of twentieth century
273 x 366 mm

Aeshna grandis, the brown hawker (upper) and *Aeschna mixta*, the migrant hawker (lower)

Rachel Ruysch is one of the earliest female artists represented in the collection and, whilst best known for her still-life paintings of flowers, she also drew insects. Both of these hawker dragonfly species are widespread. They are some of the fastest flying dragonflies and can hover and fly backwards.

Rachel Ruysch (1664–1750)
Watercolour on vellum
c. late seventeenth century
96 x 112 mm

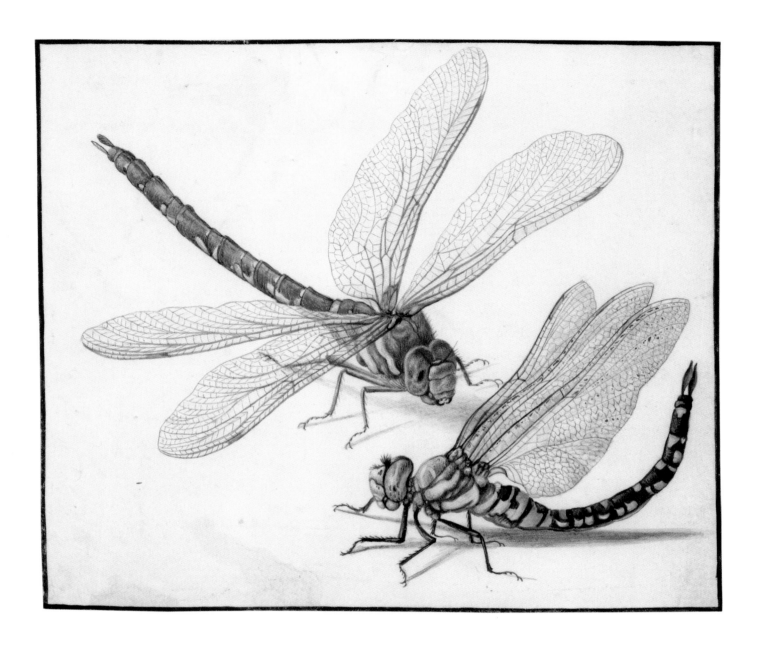

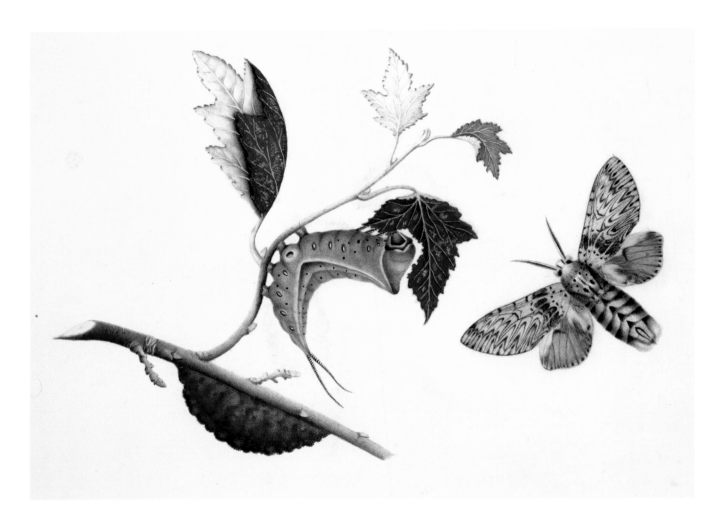

Cerura vinula, puss moth

Elizabeth Davy bred many of the subjects for her drawings.
Manuscript annotations accompany her illustrations including the
species name, collecting notes and information about the species.
Illustrated entomological publications that focused on the ecological
aspects of insects, especially life histories, have been popular since
the eighteenth century – those by Maria Sibylla Merian being a prime
example.

Elizabeth Davy (d.1836)
Watercolour on paper
*c.*1831
253 x 205 mm

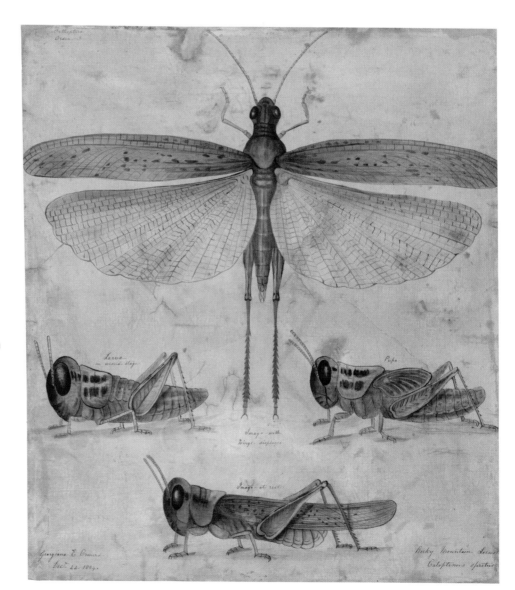

Melanoplus spretus, Rocky Mountain locust

Botany and conchology were Georgiana E. Ormerod's early interests before she turned her attention to entomology. She assisted her younger sister Eleanor, herself an eminent writer on economic entomology, in her investigations. Georgiana's illustrations were often used by her sister for her work and as lecture illustrations in agricultural colleges.

Georgiana E. Ormerod (1823–1896)
Watercolour and ink on paper
1884
610 x 503 mm

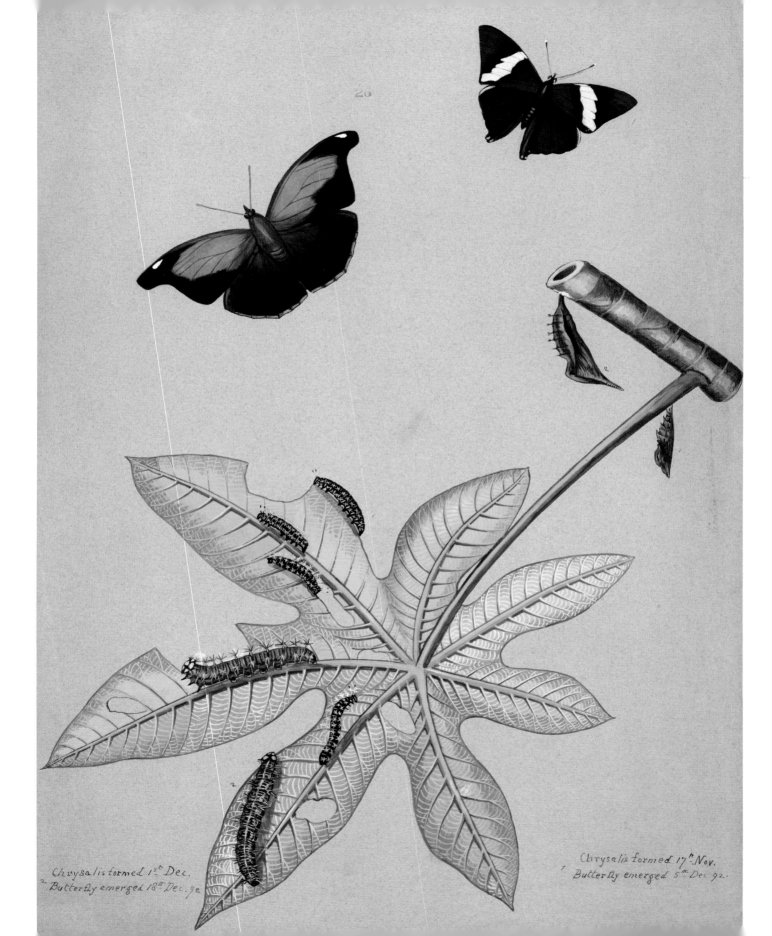

28

Chrysalis formed 1st Dec.
Butterfly emerged 18th Dec. 92

Chrysalis formed 17th Nov.
Butterfly emerged 5th Dec 92.

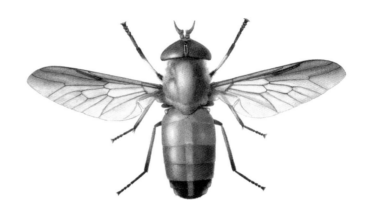

Historis odius, stinky leafwing and
Colobura dirce, zebra mosaic

Lady Edith Blake was born in Ireland. She
completed her watercolours of Jamaican
butterflies during the period when her
husband was Governor of the then
colony. The drawings depict the various
stages in the life cycle of the moths and
butterflies that she observed and reared,
as well as the damage caused to the host
plants by the larvae. They were never
published but have both scientific and
artistic interest.

Lady Edith Blake (1845–1926)
Watercolour on paper
1892
455 x 330 mm

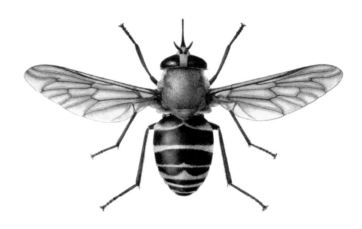

*Tabanus liventipes, Tabanus aeneus,
Philoliche angulata*, horse flies

These incredibly detailed drawings of
flies were produced for inclusion in a
work on oriental blood-sucking flies by
Ernest Austen that was never published.
Horse flies are generally regarded as
pests as they habitually attack humans
and livestock. They inflict incredibly
painful bites with their mouthparts that
pierce the host's skin like needles.

Grace Edwards (*fl*.1875–1926)
Watercolour and ink on paper
c.1906
64 x 86 mm

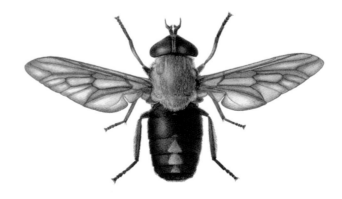

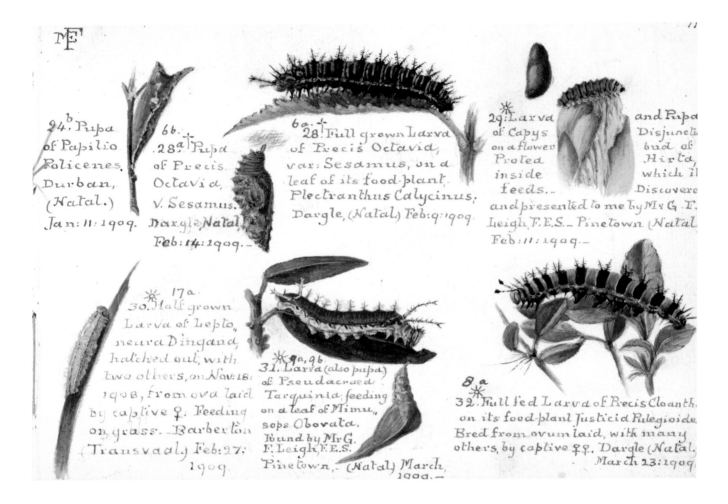

24. *Graphium policenes*, 28. *Precis octavia*, 29. *Capys disjunctus*, 30. *Dingana dingana*, 31. *Pseudacraea lucretia tarquinia*, 32. *Catacroptera cloanthe*

An adventurous traveller and collector, Margaret Elizabeth Fountaine amassed a collection of 22.000 butterflies with her partner Khalil Neimy. Her sketchbooks detail the larvae and pupae stages of the butterflies she observed, many of which she raised from caterpillars. Fountaine notes on the title page that the larvae and pupae marked with an asterisk are figured for the first time and that the species, in its early stages, had previously been unknown to science.

Margaret Elizabeth Fountaine (1862–1940)
Watercolour and ink on paper
1909
128 x 177 mm

From left to right and top to bottom:
Delias benasu (upper/underside),
Delias oraia (male upperside), *Delias
oraia* (male underside), *Delias oraia*
(female upper/underside), *Delias
blanca* (upper/underside), *Delias
elongatus* (upper/underside).

A. Ellen Prout authored many
entomological papers that were
published in journals including the
*Transactions of the Royal Entomological
Society*. She also identified and
described new species of moths. This
watercolour was published in George
Talbot's *A monograph of the pierine
genus Delias* (1928–1937).

A. Ellen Prout (*fl*.1920s)
Watercolour
c.1920s and 1930s
247 x 192 mm

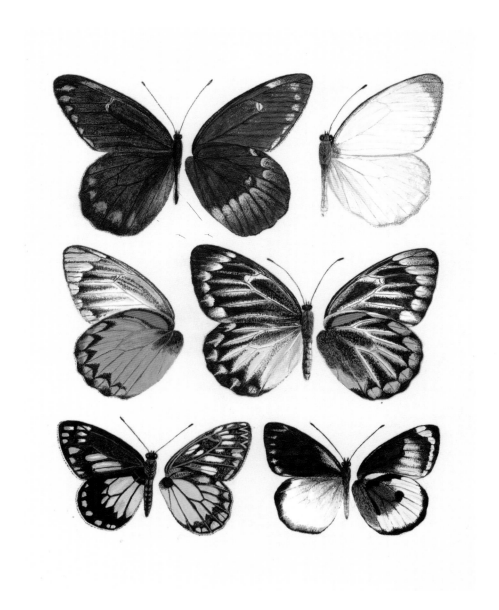

B.

Natural
size.

Phyllophaga smithi, brown hardback

A talented entomological artist, Olive Florence Tassart illustrated insects from many orders and signed all of her drawings with her initials 'O.F.T'. *Phyllophaga smithi* is an agricultural pest whose grubs damage the roots of sugarcane plants. Following its accidental introduction to Mauritius from Barbados at the start of the twentieth century it devastated the Mauritian sugarcane industry.

Olive Florence Tassart (d.1953)
Watercolour on board
c.1930s
311 x 237 mm

From left to right and top to bottom:
Apatura iris, purple emperor;
Limenitis populi, poplar admiral;
Apatura ilia, lesser purple emperor;
Apatura ilia, lesser purple emperor;
Limenitis populi, poplar admiral;
Apatura metis, Freyer's purple
emperor; *Vanessa atalanta*, red
admiral; *Charaxes jasius*, two-tailed
pasha; *Vanessa indica*, Indian red
admiral; *Nymphalis xanthomelas*,
yellow-legged tortoiseshell;
Nymphalis polychloros, large
tortoiseshell; *Nymphalis vaualbum*,
false comma; *Aglais urticae*, small
tortoiseshell; *Nymphalis antiopa*,
Camberwell beauty; *Aglais urticae*,
small tortoiseshell; *Vanessa cardui*,
painted lady; *Inachis io*, peacock;
Vanessa virginiensis, American
painted lady

Dorothy Fitchew illustrated many
botanical and entomological books. The
Library holds four of her watercolour
drawings that carefully delineate both
the upper and underside wings of
different species of butterflies from
Europe, Burma and the Middle East.

Dorothy Fitchew (*fl.*1945–1970)
Watercolour on board
*c.*1960–1970
537 x 383 mm

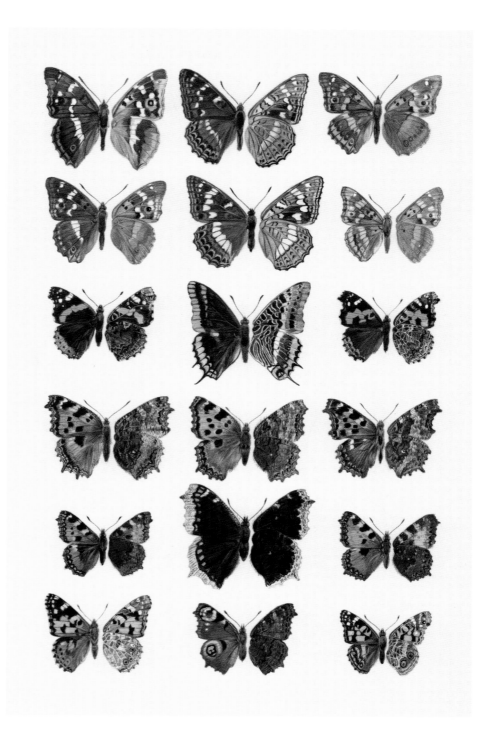

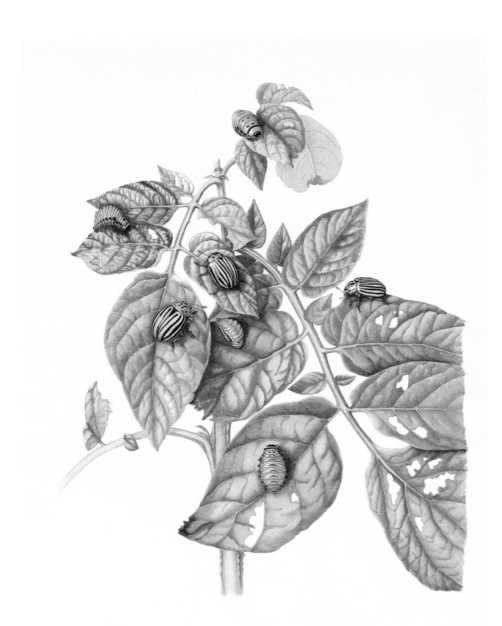

Leptinotarsa decemlineata,
Colorado potato beetle

Joyce Bee produced a range of detailed
and informative natural history posters.
Her illustrations of insects were used for
a number of entomological books whilst
her butterflies featured in a postcard
series published by the Museum. The
Colorado potato beetle is a serious pest
to potato crops as it causes significant
damage to leaves and the flowering of
the plants.

Joyce Bee (*fl.*1968–1981)
Watercolour on paper
1969
560 x 450 mm

Perca fluviatilis, European perch

Sarah Bowdich was a populariser
of natural history and science and
illustrated many of her own books.
She was the first European woman to
collect plants systematically in tropical
West Africa. Bowdich observed her
fish subjects fresh on the river bank so
that she could record their true colours
before their colourings and vitality
diminished.

Sarah Bowdich (1791–1856)
Watercolour on paper
1828
268 x 342 mm

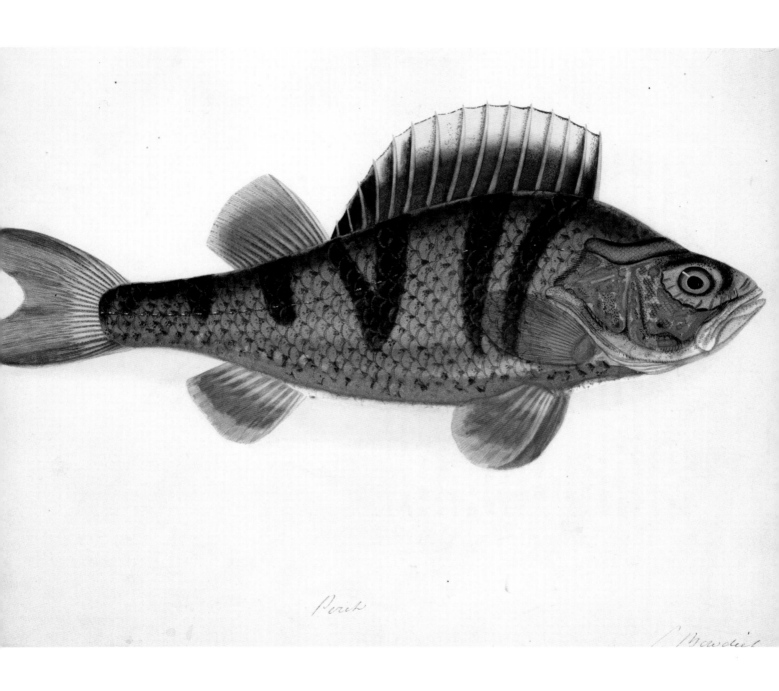

Perch

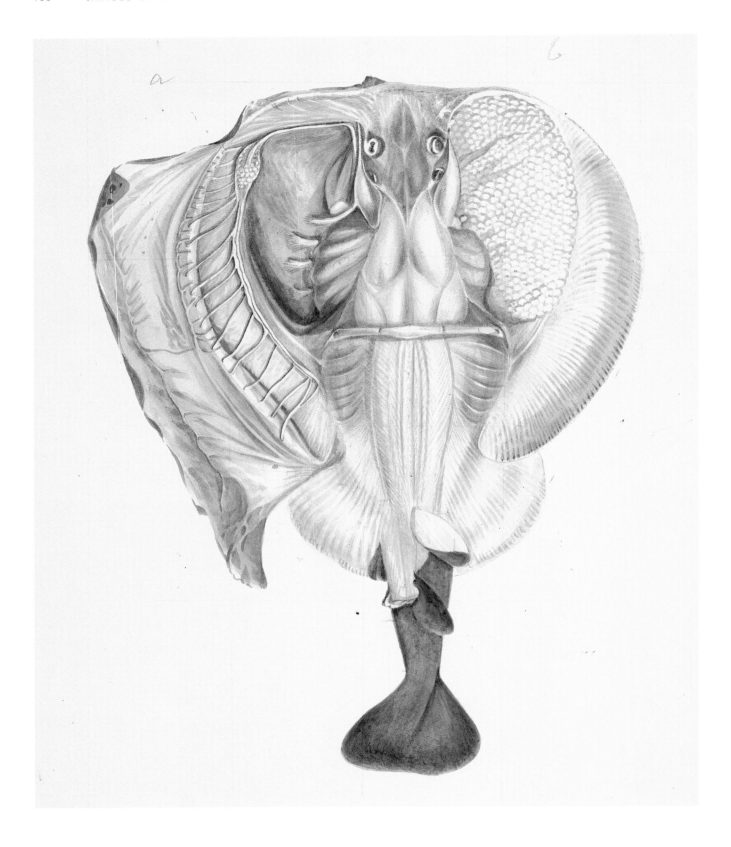

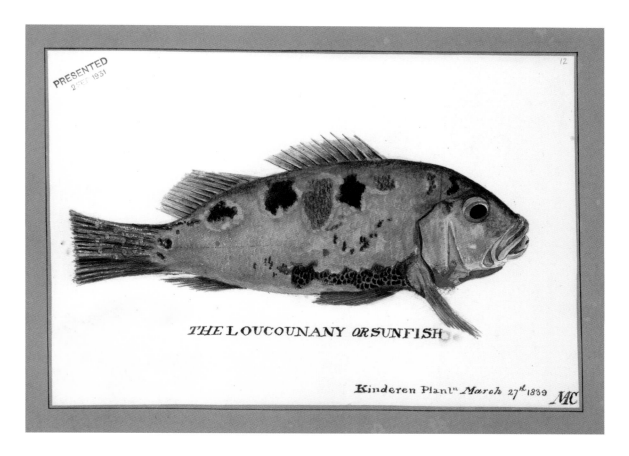

THE LOUCOUNANY OR SUNFISH

Kinderen Plantn March 27th 1839

Torpedine sp., electric ray

This illustration is from a collection of fish drawings that the Library holds by Anne Morshead. It is of an electric ray of the family Torpedinidae dissected to show the electric organs. The shocks that these fish can give have been known since Ancient Egyptian times. The electric discharges are used by the fish for defence, communication and navigation. If strong enough, it can also be used to incapacitate prey.

Anne Morshead (*fl.*1820–1830s)
Watercolour on card
*c.*1830s
254 x 199 mm

Cichla sp., South American peacock cichlid

This is one of many fishes from a volume that also included flowers and fruit from Lady Mary Anne Boode Cust's tour of the West Indies, Madeira and Tenerife in 1839. She is better known as the author of *The Cat – History and Diseases*, published in 1856. This book on cat care was much referenced by Victorian and Edwardian cat fanciers.

Lady Mary Anne Boode Cust (d.1882)
Watercolour on paper
1839
204 x 293 mm

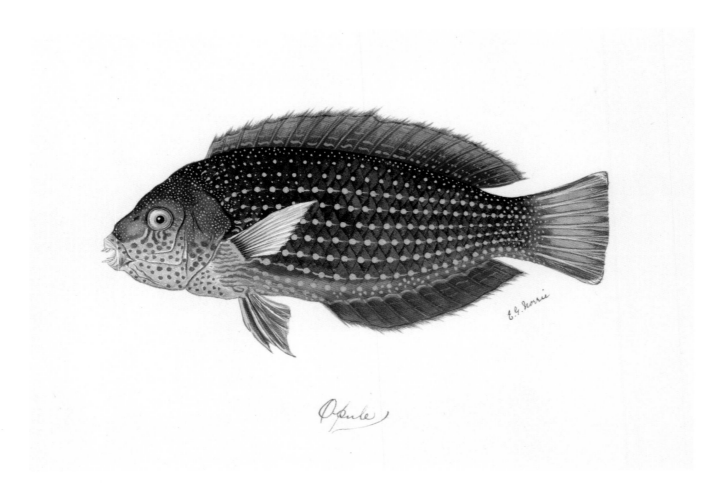

Anampses cuvier, pearl wrasse

E. Gertrude Norrie lived in California, USA and corresponded with the
Keeper of Zoology at the Natural History Museum, London, Edwin
Ray Lankester, in 1901 regarding her illustrations of Hawaiian fish. The
illustrations showcase the diverse and wonderfully coloured fish that
inhabit the Hawaiian archipelago, many of which are endemic.

E. Gertrude Norrie (*fl.*1900s)
Watercolour on paper
*c.*1900
252 x 336 mm

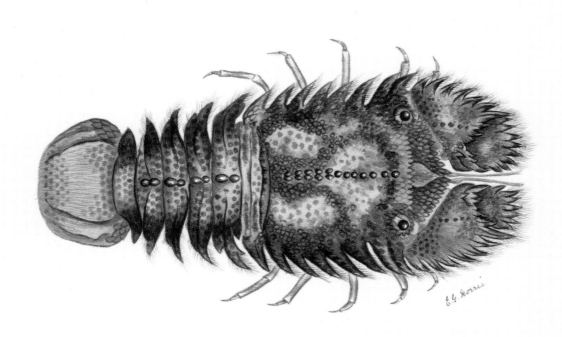

Parribacus antarcticus, slipper lobster

This second illustration of E. Gertrude Norrie is from her collection of Hawaiian fish and invertebrates. *Parribacus antarcticus* is a nocturnal species and very adept at swimming backwards at speed.

E. Gertrude Norrie (*fl.*1900s)
Watercolour on paper
*c.*1900
252 x 336 mm

Tridacna maxima, giant clam

Anna Children provided over two hundred drawings for her father's translation of Lamarck's *Genera of Shells*. She is better known for her pioneering photography work producing cyanotypes of British algae, which she published under her married name of Atkins.

Anna Children (later Atkins) (1799–1871)
Watercolour and graphite on paper
c.1820
147 x 192 mm

Fig. 1–5. *Cephalodiscus hodgsoni*, Fig. 6–8. *Cephalodiscus densus*, Fig. 9. *Cephalodiscus evansi*

Gertrude Mary Woodward was an excellent colour-wash illustrator. She was also a lifelong friend of Beatrix Potter. Her drawings of *Cephalodiscus* were published as plates in the *Zoology Report of the British Antarctic Terra Nova Expedition* 1910–1913 that was led by Captain Robert Falcon Scott.

Gertrude Mary Woodward (1861–1939)
Pen and ink wash on card
c.1918
254 x 178 mm

1.

8.

9.

2.

7.

6.

3.

4.

5.

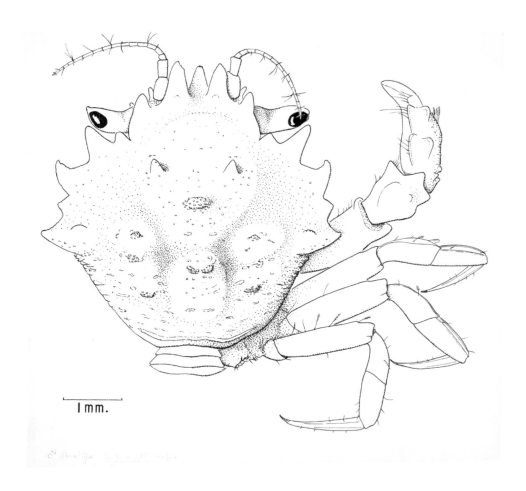

1 mm.

Sirpus monodi

Isabella Gordon was the first full-time female member of staff at
the Natural History Museum where she worked as Assistant Keeper
of Crustacea. Known as the 'old Lady of Carcinology', she was a
respected international carcinologist and illustrated her scientific
papers with simple but instructive line drawings. This illustration was
published in her paper on pygmy cancroid crabs in the *Bulletin of the
British Museum (Natural History) Zoology* in 1953.

Isabella Gordon (1901–1988)
Pen and ink on card
c.1952/3
192 x 204 mm

From top to bottom: *Cotylorhiza tuberculata*, fried egg jellyfish,
Rhizostoma pulmo, barrel jellyfish and *Aurelia aurita*, moon
jellyfish

G. W. Dalby's colourful illustrations of jellyfish were reproduced
as part of the Museum's postcard series. Her vibrant use of colour
perfectly captures their sense of shape, translucency and movement
through water. None of the jellyfish drawn are venomous. The barrel
jellyfish is one of the largest found in British waters and is a favourite
food of leatherback turtles.

G. W. Dalby (*fl*.1960s)
Watercolour on board
c.1960
460 x 292 mm

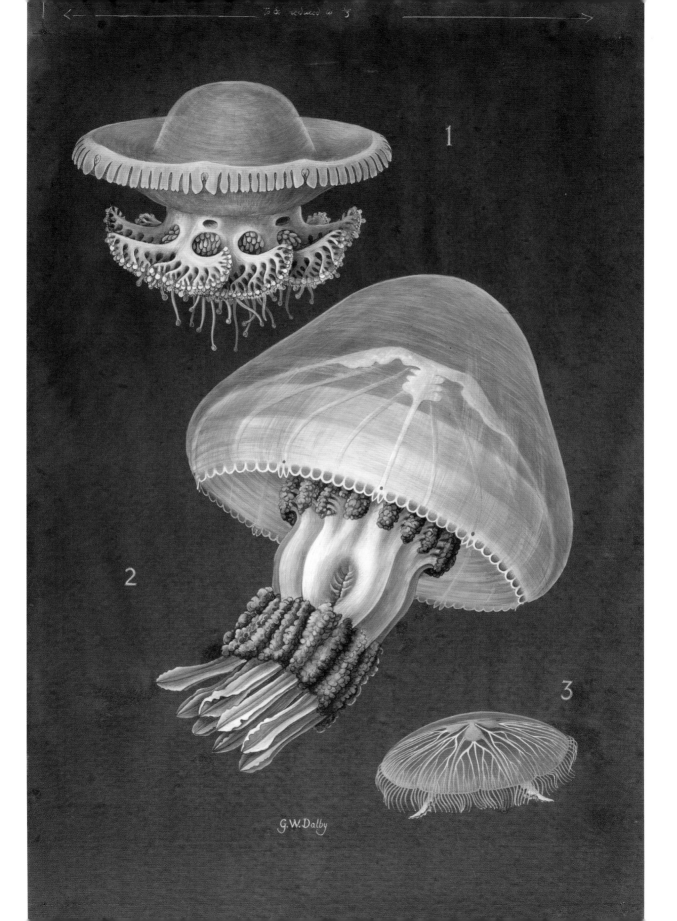

To be reduced to ⅔

1

2

3

G.W.Dalby

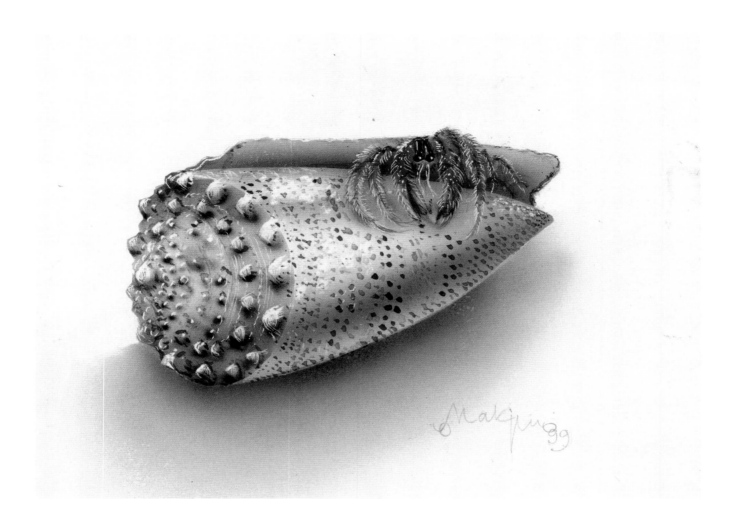

Conus arenatus and hermit crab

In this second illustration of Olga Makrushenko, she once again uses her skills to effortlessly capture the three dimensionality of this sand-dusted cone, and the hermit crab that made the shell its temporary home, to stunning effect.

Olga Makrushenko (b.1957)
Mixed media on card
2000
81 x 101 mm

Liroconite

Mrs Rachel Gould was the sister of Philip Rashleigh, Cornwall's most famous antiquary and mineralogist. She assisted in the illustration of the second volume of his *Specimens of British Minerals*, published in 1802. This illustrated *Liroconite* specimen, from the Wheal Gorland mine, is still the largest crystal of its type known, and is in the mineral collection at the County Museum, Truro.

Mrs Rachel Gould (1739–1829)
Watercolour on paper
*c.*1800
202 x 247 mm

Miss F. Rashleigh.

Clinoclase, azurite or cyanotrichite

Miss F. Rashleigh was related to the famous Cornish mineral collector Philip Rashleigh. This illustration of a *Clinoclase*, from Rashleigh's collection, is of a specimen found in the famous Wheal Gorland mine in Cornwall where it was first described in 1801 as a cupreous arsenate of iron.

Miss F. Rashleigh (*fl*.1800)
Watercolour on paper
c.1800
159 x 187 mm

Mammuthus primigenius, woolly mammoth

Alice Bolingbroke Woodward was a prolific illustrator for both scientific works and children's books. Her palaeontological illustrations reflect the reconstruction style that was popular at the time with other artists such as Benjamin Waterhouse Hawkins (1807–1894) and Neave Parker (1910–1961).

Alice Bolingbroke Woodward (1862–1951)
Graphite and white on paper
c.1924
185 x 127 mm

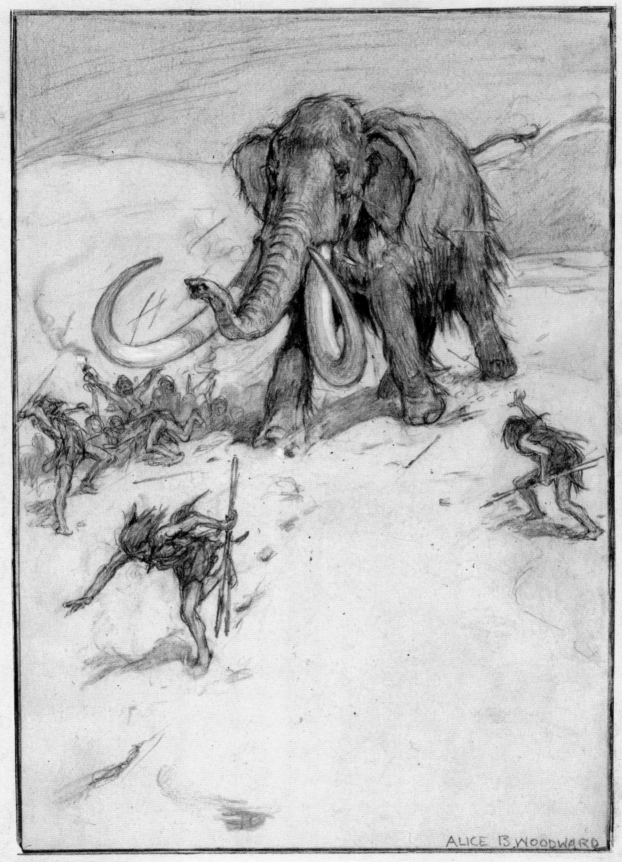

ALICE B. WOODWARD

MAMMOTH

Index

Page numbers in *italic* refer to illustration captions.

Abbot, Sarah 10
Anning, Mary 6
authorship by women 8

Balston, Emily J. *27*
Barbiers, Maria Geertruida *25*
Baret, Jeanne 10
Basseport, Madeleine *16*
bean broomrape 58
Bee, Joyce *98*
Begonia luxurians 64
Bentinck, Mary *77*
Bewsher, C. W. W. *38*
bird of paradise flower *27*
birds 5, 14, *73–87*
Blackwell, Elizabeth 8
Blake, Edith 12, *93*
Blandford Lewis, Olga *68*
Boode Cust, Mary Anne *101*
borage *37*
botany, influence of 5, 6, 7–8
Bowdich, Sarah 8, *98*
Brasier, Jenny *64*
Bredia fordii 52
bromeliad *54*
brown hardback *96*
Burrard, Laura *43*
Bussey, Winifred *57*
butterflies and moths *2*, 10, 11, 12, 90, *93–5, 97*
Butterworth, Elizabeth 14, *87*

Cameron, Elizabeth *60*
castor oil plant *27*
Cephalodiscus sp. *104*
Children (Atkins), Anna 9, *104*
Chinese lychnis *21*
Clinoclase 110
Cockburn, Margaret Bushby Lascelles *79*
cocoa tree *40*
Colden, Jane 7, *27*
Coley, Hilda Maud *52*
Colorado potato beetle *98*
Conus arenatus 108

Corfe, Beatrice *51*
correspondence 6–7
crabs *106, 108*
crenate orchid cactus *52*

Dalby, Claire *60*
Dalby, G. W. 14, *106*
dandelion *57*
Davy, Elizabeth *90*
Davy, Joanna Charlotte *47*
Dawson, Muriel Helen *83*
Delany, Mary 7, *57*
dragonflies *2, 88*
Drought, Isabel *34*
Duppa, Adeline Frances Mary *40*

Eaton, Mary *49*
Edwards, Grace 13, *93*
electric ray *101*
elephant-eared saxifrage *72*
Encephalartos longifolius 33
Eucalyptus sp. *57*
European fire-bellied toad *13*
European perch *99*
Everard, Barbara *58*

family influences 8–10
Fenwick, Susan Catherine *77*
fern *58*
fish *98–102*
Fitchew, Dorothy *97*
flame freesia *21*
Flower, Lilla *88*
Fountaine, Margaret Elizabeth 11, *94*
Fritillaria imperialis 30
fruit *2*, 18, *34, 38, 64, 68*
fungi 6, *43, 49*

giant clam *104*
gila monster *88*
Gladwell, Angela *84–5*
Godfery, Hilda Margaret 10, *46*
Gordon, Isabella *106*
Gould, Elizabeth *75*
Gould, Rachel *109*

Gray, Asa 7
Gregory, Norma *72*
Grierson, Mary *58*
Gwatkin, E. N. *43*

Hardcastle, Lucy *30*
Hawkins, Ellen *23*
Hayden, Toni *64*
hazel *43*
Helianthus tuberosus 63
horse flies *93*
horse-heal *28*
Huysum, Maria van *18*

Ibbetson, Agnes 7, *28*
insects 9, 11, 12, 13, *88–98*

jellyfish 14, *106*
Jewell, Rebecca *87*
juniper *51*

Latham, Ann *73*
Lawrance, Mary 10, *21*
Lee, Ann 9, *9*
lichen *60*
line drawings 14, *106*
Liroconite 109
Lister, Gulielma 7, *39*
Loudon, Jane 8

Magnolia sp. *2, 69*
mahogany *71*
Maitland, Lorna *57*
Makrushenko, Olga *68, 108*
Medland, Lilian *80*
Mee, Margaret 12, *54*
Meen, Margaret *18, 23*
Merian, Maria Sibylla 10, 10–11, *90*
mesembryanthemum *9*
Mesembryanthemum sp. *17*
Metz, Gertrude *21*
minerals *109–10*
Moon, Maley C. *34*
Morse, Annie (Mrs H. B. Morse) *44*
Morshead, Anne *101*

Moseley, Harriet *36*
Moser, Mary *18*
mountain ash *50*

Narcissus sp. *30*
nests and eggs *79*
Nicholson, Barbara 14, *62*
nodding sage *16*
Norrie, E. Gertrude *102, 103*
North, Marianne 11
Nymphaea odorata 44

orchids 10, *46–7, 67, 68*
Ormerod, Eleanor *91*
Ormerod, Georgiana E. 9, *91*
Ormerod, Sarah 9, *79*

palaeontology 6, 9, *110*
pea *71*
pearl wrasse *102*
peony *2*, 31
Phillipps, Frances Anna M. *28*
plants 6, 7, 7–8, 9, 9–10, 12, 14, *16–72*
Plues, Margaret *37*
Pope, Clara *18, 30*
Populus tremula 44
potato bean *27*
Potter, Beatrix 6, *104*
prayer plant *67*
Primula sp. *30*
Procter, Joan Beauchamp *13*, 14
Prout, A. Ellen *95*

rain lily *18*
Rashleigh, F. *110*
rhododendron *60*
Rocky Mountain locust *91*
Rosa sp. *7, 23, 30*
rose mallow *34*
Ross-Craig, Stella 14, *52*
Russell, Anna *32*
Ruysch, Rachel 9, *88*

sand sedge *28*
scientific illustration 12–14
scientific societies 5, 6, 15, *32, 95*

seaweed 10, *62*
Sellars, Pandora *67*
shells 9, 14, *104, 108*
Sirpus monodi 106
slime moulds 7, *32, 39*
slipper lobster *103*
Smith, Matilda 13, *24*
Snelling, Lilian 13, *50*
South American peacock cichlid *101*
Spanish flag *40*
Sparmannia discolor 24
stinking iris *36*
Stone, Sarah 14, *75*
Stones, Margaret 13, *63*

Talbot, Dorothy *49*
Talbot-Kelly, Chloe *83*
Tassart, Olive Florence *96*
Tcherepnine, Jessica *71*
Tebbs, Margaret *66*
Temple, Vere Lucy *54*
thistles *23*, 54
Thursby-Pelham, Dorothy Elizabeth 6–7, *80*
Tolpis farinulosa 66
Tonge, Olivia 5, *5*
travel by women 10–12
Trichia affinis 39
tulips *2*, 10, *25*
Turner, Mary 10
Twining, Elizabeth *7*, 8

Uvariastrum zenkeri 49

water lily *44*
Webb, Jean *71*
wintergreen *27*
Withers, Augusta Innes *33*
Withoos, Alida 9, *17*
Woodward, Alice Bolingbroke 9, *110*
Woodward, Gertrude Mary 9, *104*
woolly mammoth *110*
Woolward, Evelyn M. *40*
Woolward, Florence Helen *44*